Peter Paul Rubens
Life and Work

About the Author

Martin Warnke, born in 1937 in Ijui, Brazil, studied art history, history, and German in Munich and Berlin. 1960-1961: On scholarship in Madrid. 1964: Graduation with a dissertation on Rubens' letters. 1964-1965: Volunteer at the Berlin-Dahlem State Museums. 1965-1967: On scholarship in Florence. 1967-1971: Assistant in the art history seminar of the University of Münster. Since 1971: Professor of art history at the University of Marburg. Publications include *Commentaries on Rubens* (Berlin, 1965), *17th Century Flemish Painting* (Berlin, 1967), and *The Work of Art between Science and Worldview* (Gütersloh, 1970).

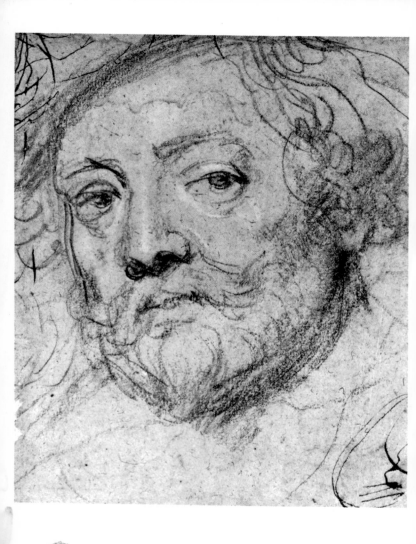

Self-Portrait. Ca. 1635–1640

Contents

Preface ix

I. THE PERSONAL SPHERE 1
 The "Honeysuckle Bower" — Childrens' Portraits — Por-
 traits of Isabella Brant and Helena Fourment — Self-
 Portraits — The House

II. THE HUMANISTIC AND ECCLESIASTIC SPHERES 32
 Rubens in the Humanists' Circle — Early Altars — De-
 velopment of His Style — Allegories — Altar Paintings to
 1628 — Landscape Paintings — Portraits

III. THE POLITICAL SPHERE 113
 The Duke of Lerma on Horseback — Municipal Commis-
 sions — Hunting Pieces — The Great Court Cycles —
 Allegorical Language — Allegories of War and Peace

IV. THE ARTISTIC SPHERE 138
 Representation of Emotional States — Selected Individual
 Figures — Mythological and Social Pieces — Late Altar
 Paintings — Arcadian Themes — The Atelier — His Work
 Method

Appendix
 Texts by Rubens on Art 173
 Suggested Reading 187
 List of Color Plates 191
 List of Black and White Illustrations 193
 Photographic Credits 199
 Rubens and His Times (Chronological Table) 201

Preface

The subtitle "Life and Work," which has been common for monographs on artists since the last century, usually implies that the work of an artist concurrently mirrors his life and that his life is directly actualized in his work. Thus it is expected that a monograph on an artist will describe his works as an emanation from his life and his life as a culture-medium for his works.

In the case of Peter Paul Rubens this interconnection of life and work has led to a series of questionable opinions. It could be concluded that the large formats of paintings, which are often dubbed "monstrosities" by museum-goers, are the result of an unbounded creativity; the passionate altarpieces, of an ardent faith; the painstaking allegories on state leaders, of devoted humility; and the numerous naked women, of an almost uninhibited lust for life in the flesh.

We do not, however, depend on Rubens' painting to formulate our judgments on his life style. His correspondence alone comprises several imposing volumes. All the testimony we possess from him or from contemporary observers, though, evinces a prudent, open, critical, and uncommonly well-read man, who arranged the scope of his life in a thoroughly middle-class, cautious, and resolute manner. Rubens' capacity for organization and management manifests itself in the manner in which he maintained the productivity of his atelier of numerous assistants, arranged and concluded his diplomatic activities, and carried out his artistic, business, and familial affairs. Hardly anything articulated in Rubens' works can be attributed to his life as well.

Adherence to the usual subtitle is justified less by the supposition that Rubens' works present themselves as emanations from or evidences of his life than by the insight that the works are counterproposals to his actual life. Painting confronts life with the claim that it is a peculiar mode of understanding and experience. In order to make clear in this sense the particular stamp of Rubensian painting, we will base our examination on three external factors. In the first chapter we treat paintings which owe their occasion and their subject matter to the artist's personal sphere. In the second chapter the humanistic and ecclesiastical environment is presented, like the personal environment, as a source of stimulus which Rubens exhausted, rather than just simply expressed. Even those assignments Rubens accepted from the political world, which we treat in the third chapter, were not carried out merely as a routine, seigneurial requirement. In the last chapter, in addition to his later works, a few of the techniques Rubens developed for his world of images are discussed.

Each chapter is intended to address from a different perspective the question of what in Rubens' work has been retrieved from his life, in order that we might reflect upon it with reason.

I. THE PERSONAL SPHERE

The painting in the Munich Alte Pinakothek in which Rubens has portrayed himself and his wife Isabella Brant before a honeysuckle bower is the first in a series of pictures in which the painter presents his domestic and familiar surroundings (color plate 1).

Until c. 1610, when the picture was produced, Rubens had as yet hardly experienced an uninterrupted, simple domesticity. His father, Jan Rubens, had been educated in Padua, received his law degree in Rome, and been an alderman for the city of Antwerp. As a Calvinist he had fled that oppressed city in 1568 for Cologne. There he became advisor to the wife of William of Orange, was soon found guilty of breaking up that marriage, and was thereafter imprisoned in the fortress at Dillenburg. William of Orange used Jan Rubens' confessions to obtain a divorce from the troublesome, scheming Ann of Saxony. Thanks to this by-product and perhaps also to the noble supplications of his wife, Jan was allowed in 1573 to live under house arrest with his family in Siegen. Under these circumstances Peter Paul Rubens was born in Siegen, the next to last of seven children, in June 1577. A year later the family was allowed to move to Cologne, where his father, who had since returned to the bosom of the Catholic Church, entered into extensive trade. When the father died in 1587, Rubens' mother returned to Antwerp with the four surviving children. There Peter Paul attended grammar school, though his mother said the fourteen-year-old lived outside the house and looked after himself. For a short time he was a page at a countess' country manor before he followed his eldest brother's example and began to study painting. He changed masters three times. Tobias Verhaecht, Adam van Noort, and Otto van Veen introduced him to a

stimulating, manneristic world of forms. In 1598 he became a master and member of the Guild of St. Luke.

Completely in keeping with this apprenticeship, he set out in 1600 for Italy, where he immediately assumed the post of court painter to Gonzaga in Mantua, a position which also made it quite possible for him to further his education. In 1601 Rubens was already in Rome, where he painted three altarpieces for a chapel in Archduke Albert's namesake church. Governor of the Spanish Netherlands since 1595, the archduke had stepped down from his post as cardinal when he married the infanta Isabella in 1599. In 1603 the duke of Mantua dispatched Rubens to Valladolid with gifts for the Spanish court. Only between 1604 and 1605 did Rubens fulfill his post as court painter in Mantua itself. During this time he painted three large canvases for the choir of the Jesuit Church at Mantua. These paintings have been cut up in part and are today scattered among several museums. After several brief visits to Padua and Genoa, Rubens was again in Rome in 1606 with his brother Philip. Although the Mantuan duke was supporting his studies, he undertook the most outstanding commission available in Rome at the time: the painting — which he had to paint twice — for the high altar of the oratory church of Santa Maria in Vallicella (fig. 62).

When he received the news of his mother's ill health in 1608, he felt justified in returning to Antwerp without the permission of his employer. There all efforts were made to convince him to stay. Rockox, the mayor, had him paint an *Adoration of the Kings* in the same room of the town hall in which the twelve-year armistice with Holland would be signed (fig. 56). Above all, the prospects opened up by this commission, with which Philip Rubens had also become passionately involved, induced Rubens to remain in Antwerp. In 1609 he was named court painter to Albert and Isabella at a yearly salary of one thousand guilders. Further, he was not obliged to reside in Brussels, was exempt from taxes, and was allowed to employ as many assistants as he saw fit. Thus, materially assured of his future prospects, in October 1609 Rubens married Isabella Brant, the eighteen-year-old daughter of a respected lawyer of the city, in whose house the couple would also live at first. In 1610 Rubens acquired the plot of land on which his house, still preserved today, would be built in the following years (fig. 19).

A painting in the Munich Pinakothek shows the widely traveled

man with his newly wedded wife under the tranquil shade of a honeysuckle bower (color plate 1). One of the most striking features of the picture is its size. The canvas, which has perhaps been trimmed down, allows the life-size figures to advance into the foreground. Before this time a life-size, full-length self-portrait of an artist with his first wife had never been done. Traditionally, domestic portraits of husbands and wives were, on the whole, small paintings of only the upper halves of their bodies, and when they did appear full-length, the couples were placed in a rather rigid relationship to one another. In the Camera degli Sposi in Mantua, Rubens had seen Lodovico Gonzaga and his wife painted around 1465 by Mantegna as a seated couple encircled by their family. But even in this fresco, the pair had not yet acquired the intimate interrelationship perceptible in the Munich portrayal. The full-length portrait was a likeness painting and scarcely evoked personal emotions. In his husband and wife portrait, however, Rubens did loosen the formality adhered to in that genre of painting. He is sitting casually on a post with legs crossed, his cloak placed across his lap, so that his splendid, patrician clothing remains completely visible. She is seated, also in festive holiday dress, on a pillow on the ground. From beneath the large hat atop the Dutch bonnet, she, like her husband, looks out at the viewer. The gay patrician costume, presented in metallically vivid colors, does not, however, inhibit the almost playful contact the couple has with one another. Inside the oval in which they are inscribed compositionally, three points of contact take place: the artist's right hand rests on his knee, "where his hand receives that of his wife" (as expressed in the catalog of the Düsseldorf Gallery, which acquired the picture in 1778 after Rubens' death). Below, a fold of her dress lies over his right foot; above, her hat touches the man's left arm. There his hand casually holds the ornate hilt of the sword, and he points with his index finger toward their joined hands in the picture's center. The contact thus established allows narrative intentions to enter into the representational full-length portrait.

The fundamental constitutive elements of this portrait of a married couple — the garden bower, the casual seated position, and the intimate relationship — are drawn from the tradition of popular portrayals of loving couples. Around 1600 the young Rubens had himself already drawn such a loving couple after an etching by Meckenem (fig. 1) in the manner customary since the late Middle

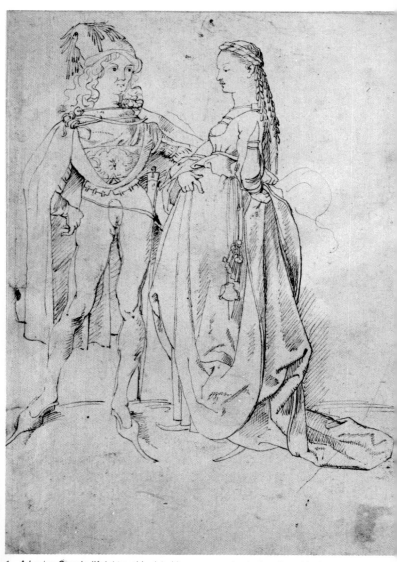

1 *A Loving Couple (Knight and Lady)*. After an engraving by Israel van Meckenen. Before 1600.

Ages. Traditionally, they could also have been shown seated and in front of a honeysuckle bower. Later on, the scene found its way into emblem books; Alciatus reprinted it in 1522 as an example of marital fidelity (fig. 2). The seated position of this Alciatus emblem, according to a contemporary of Rubens, signified "steadfastness in love," because a seat must stand firm; the dog was a "champion of faithfulness," the apple tree, the tree of Venus. The holding of hands, the *iunctio dextrarum,* meant harmony, *concordia,* in other realms of life as well.

Rubens' *Honeysuckle Bower* is reminiscent of this emblem, though he modifies the abstract signs in terms of an experience capable of being reconstructed. The dog as a symbol of faithfulness is left out, as is the fixed bench, since their meaning becomes evident in the actual attitude of the figures. Even the fixed grasp of the hands, which indicated a contractual obligation, he modified so that the hands come together voluntarily. He abstained, however, from every sacramental consecration of the marital union as it had still been, for example, so clearly retained in the so-called *Arnolfini Marriage* by van Eyck, although marriage had in the meantime become a sacrament. Rubens describes here a marital understanding which no longer views marriage as merely a pact toward the betterment of an economic foundation, but rather as a consummate union of natural preferences. When he wrote about his brother's wedding that something like this should not be treated "coldly," but "with great ardor," Rubens indicated that he no longer looked upon marriage as a contract, but as a natural event. When he allowed narrative elements from the tradition of love portraiture to infuse the representational, full-length portrait, he created the pictorial formula for a concept of marriage which favored the inclusion of emotional and natural inclination and love. This was a notion of marriage also founded in a conception emanating from the private sphere of the middle class, which stood in opposition to the ostentatious sphere of the court and aristocracy, for whom marriage was arranged according to societal status and utility. Demonstrable characteristics of the portrait indicate that it is not the result of an incidental mood, e.g., the diagonally placed folds and crossed legs create a sense of distance to the viewer which protects the couple at any proximity; documentary exactitude is achieved by the cool, natural colors and by the rigid contour drawing, as well as by an unintersected representation of the

In fidem uxoriam. LXI.

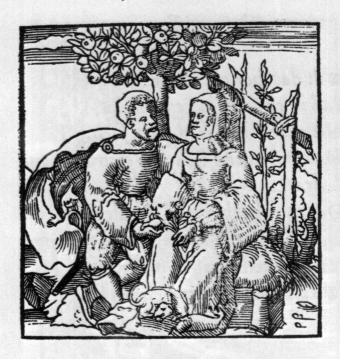

Ecce puella uiro que dextra iungitur, ecce
 Vt sedet, ut catulus lusitat ante pedes?
Hæc fidei est species, Veneris quam si educat ardor,
 Malorum in læua non malè ramus erit:
Poma etenim Veneris sunt, sic Scheneida uidt
 Hippomenes, petijt sic Galathea uirum.

2 Andrea Alciatus: *Emblemata*. Lyon, 1551 (First edition 1522).

figures. These characteristics led Jakob Burckhardt to doubt Rubens' authorship and Gustav Glück to suspect that it was conceived after Isabella's death. Dutch painting, in grasping onto the Rubensian pictorial formula like a catch phrase, also preserved these characteristics in images of mature marital relationships. Even today the form of self-representation presented in the *Honeysuckle Bower* is retained in countless wedding photographs. The fact that often the ceremonial element thereby steps even more strongly into the foreground can confirm that Rubens, in the *Honeysuckle Bower*, had less an actual than an imagined state of being in his mind's eye and that he created the painting as a fundamental contribution to a new form of interpersonal relationship. That Rubens never again demonstrated this conception of marriage either through his own example or through that of others also suggests this. He did, however, generalize the pictorial formula of the honeysuckle in ever new varieties.

A painting from around 1613 in which Rubens portrayed the antique painter Pausias and his beloved Glycera can be regarded as a self-portrait in disguise (fig. 3). Pausias is showing Glycera the floral piece he painted, while she braids wreaths of flowers, an activity at which she was supposed to have been especially skilled. This scene was viewed as a "struggle between art and nature." Even the first written testimony on the *Honeysuckle Bower*, a poem from 1612 by the Dutch humanist Baudius, sees a consummate harmony demonstrated in the husband and wife portrait and "a quarrel purely over who exceeds the other in faithfulness and devotion." This poem might have induced Rubens again to take up the theme in the Pausias and Glycera version and to have Osias Beert paint the flowers. Later on Rubens used the same pictorial formula once more in the representation of the Four Corners of the World, in Mars and Venus, and preeminently in that paragon of divine couples, Juno and Jupiter, as if the gods should set an example for men. In such treatments the content of the early husband and wife portraits appears generalized and no longer tied to individuals (fig. 4, color plate 11). It is remarkable that Rubens did not take part in the development of family portraiture, which was so intensively cultivated during the seventeenth century, particularly in Antwerp. At the same time as the *Honeysuckle Bower*, the family portrait in Karlsruhe (fig. 5) was produced, in which a child lovingly caressed by his father restores the connecting link between two aging marriage partners. The picture is also ascribed to Cornelis de Vos, who

3 *Pausias and Glycera* (Flowers by Osias Beert). Ca. 1613.

preeminently was to bring the life-size family portrait to flower in
Antwerp. While other artists in Rubens' circle — David Teniers, for
example — were able to portray themselves proudly together with
their families, Rubens only painted details, as it were, of his family;
we have portraits of his children, of his wife with the children or by
herself, and finally self-portraits, but no portrait of the entire family.

The drawings and sketches in which Rubens portrayed his chil-
dren have been disseminated in numerous reproductions (fig. 6) and

4 The Front of the Triumphal Arch of Philip (engraved by Theodor van Thulden after Rubens' model). 1635. Antwerp.

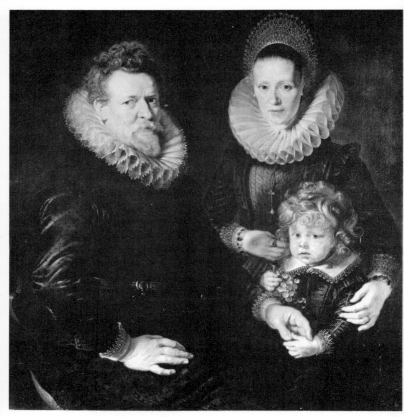

5 *Portrait of a Couple with a Child.* Ca. 1609.

displayed in nurseries, in children's clinics, or in the waiting rooms of pediatricians. A sense of the uniqueness of the child's nature has been worked out in them, that only became universal as a basic pedagogical fact centuries after Rubens. For Rubens such drawings were multifarious material, models which he then utilized for his compositions often replete with children. Even the beloved *Boy Playing with Bird* (fig. 7) was at first intended for this application. The head of the child reappears exactly in the picture *The Madonna*

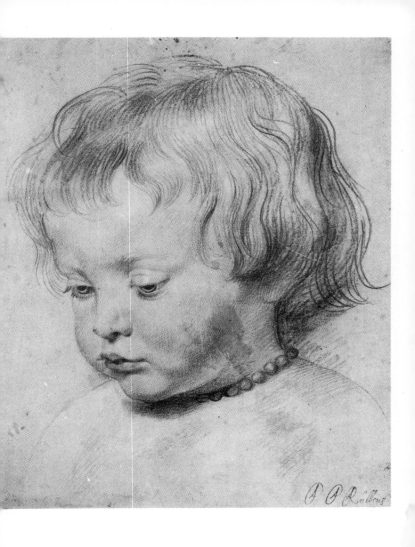

6 *Portrait of a Child* (probably Nicolas Rubens). Ca. 1619.

Surrounded by Garland and Boy Angels (fig. 8), in the upper right-hand corner. The wood panel on which the boy with the bird is painted was originally smaller and was later widened on the left-hand side with an additional diagonal piece. Even the style of painting indicates that Rubens placed the bird in the child's hand only after the fact. Playing with birds in this manner was a much-loved pastime of children at the time and as such often occurs in Rubens' works. This motif, however, also plays a part in Christian iconography: when the Christ child plays with a bird, it is a reference to his future death, the bird being interpreted as a soul in flight (fig. 9). At the time, a father whose child had died could be consoled with the commentary found on ancient tombstones that bore pictures of children with birds: "Life is like playing with birds; sometimes it flies away quickly." That this theme motivated Rubens, who lost a daughter in 1623, to widen the portrait cannot be proved with certainty.

Play with a bird also appears in the portrait of his sons Nicolas and Albert (fig. 10), in which no reference is made to an allegory of death. Whereas Nicolas gazes at the bird he has tied on a leash, Albert looks thoughfully beyond it while clutching a book on his right hip; he rests his left arm on his brother's shoulder and dangles his glove in aristocratic fashion. In the literature on art of the time, an account from Plinius was often referred to which told how Parrhasius had proved himself a master at representing internal and external expressions of mood when he painted two children, one of whom embodied the lightheartedness (*securitas*) and the other the naivete (*simplicitas*) of their respective ages. "Particular duties are imposed on every age group," Rubens' brother once wrote; in this example schoolwork and play are the assignments. Albert would, incidentally, be educated as an archeologist, whose writings on the *Gemma Augustea* (cf. fig. 28) have just recently been deemed worthy of republication.

Rubens never portrayed his wife Isabella Brant with her children, but often, however, alone. One of the most beautiful of these portraits is preserved in the Uffizi (fig. 11). Her face, visibly aged, set against a deep red, luminous background, is bent slightly forward, and her gaze is unquestionably directed toward the viewer. While the left hand is drawn back on the breast in a gesture of sorrow, she holds a book of consolation in her right hand. The vine-entwined column in the background also implied reflections on

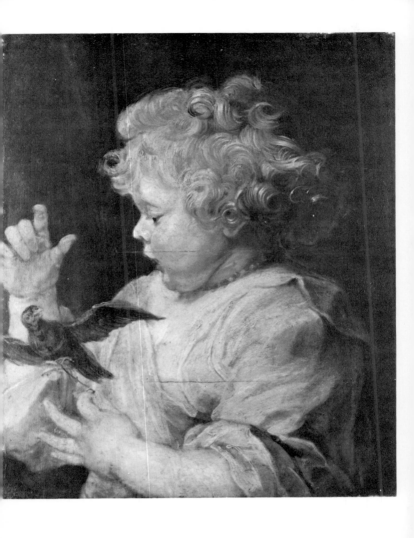

7 *Boy Playing with Bird*. Ca. 1616.

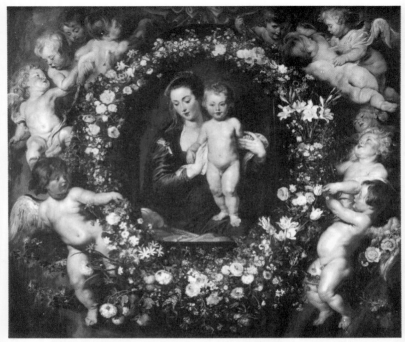

8 *The Madonna Surrounded by Garland and Boy Angels* (Flowers by Jan Brueghel the Elder). Ca. 1620.

death, since it can signify, according to emblematic literature, "friendship which lasts even beyond death." This portrait was probably painted at the end of 1623, soon after the death of their daughter, Clara Serena. Isabella herself died in June of 1626.

"I have decided to marry again, since I do not yet sense a tendency towards the continence of bachelordom . . . I have taken a wife from a good, though middle-class, house, though everyone tried to convince me to establish a household within the aristocratic circles. But I was afraid of the well-known negative quality of nobility, that conceit particularly evident in the opposite sex; therefore I preferred to take a wife who would not blush upon seeing me take up my brush. And to be truthful, I would find it very dififcult to exchange

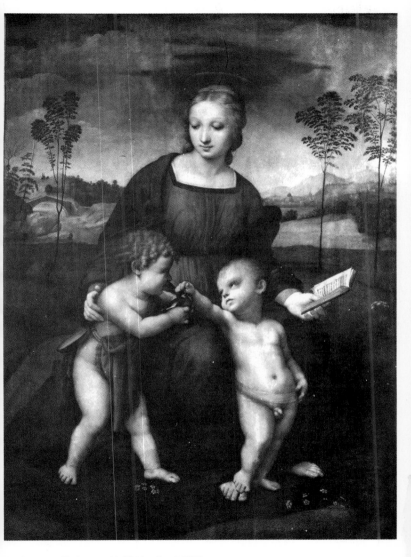

9 Raphael: *Madonna with Siskin*. About 1506.

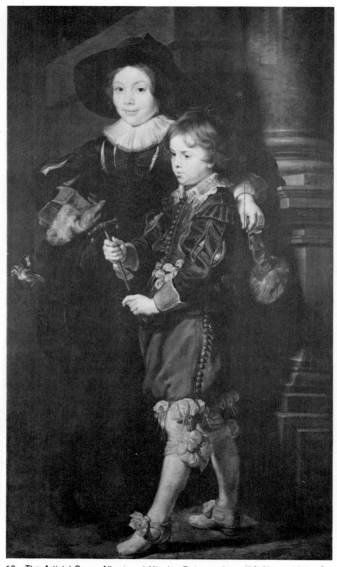

10 *The Artists' Sons, Albert and Nicolas Rubens.* Ca. 1626.

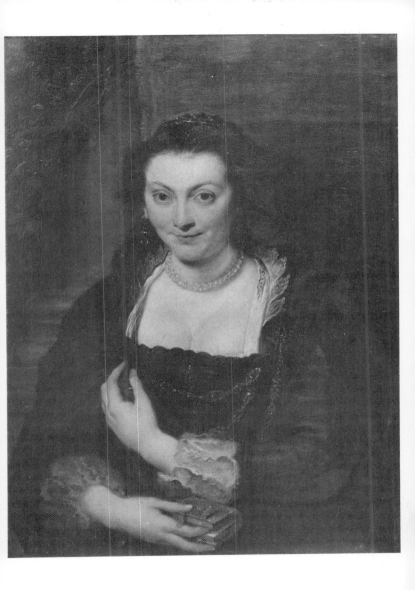

11 *Isabella Brant*. Ca. 1623.

that precious treasure of freedom for the loving caresses of an old woman." With these words Rubens explained why, after years of active political engagement, he married the sixteen-year-old Helena Fourment in December 1630. Though his choice clearly expresses the peak of his antiaristocratic sentiments, Helena began his involvement with a new generation of the middle-class, which did not lend itself to being simply placed before a honeysuckle bower, having been, rather, always on the verge, so to speak, of springing into a more elevated circle. Rubens himself was granted knighthood by the king of England a few days after the wedding. A year before he had been awarded the Master of Arts degree in Cambridge. As early as 1624 the Spanish king had raised him to the modest rank of peer. In all West European monarchies the absolutist courts had readied the ladders so eagerly climbed by those in middle-class circles anxious to improve their social status.

Even the portraits Rubens made of his family and himself mirrored this upward mobility. A painting at the Munich Pinakothek shows Helena Fourment with her firstborn son, Frans, sitting on a terrace in an ornate settee (fig. 12). As in portraits of the aristocracy, a red-violet drape is swung about a column as a mark of nobility. Undoubtedly, within this representational framework, moments are reflected which were nurtured by that middle-class freedom Rubens wanted to retain. The picture does not acquire its own dimension solely from its close relationship to the portrayal of a Madonna and child. In contrast to the usual practice in aristocratic portraits of a seated figure, the majestic column is not included to add support to the spine; on the contrary, the mother holding her naked son in her arms forms a self-sufficient counterweight to the vine-entwined column. The plumed hat worn by the naked youth lends a lively contrast. The bright and airy unconstrained colorfulness, only adumbrated by Rubens and filled in by a colleague later on, lays the ground for the picture's open feeling, from which the woman's gaze — as if summoned — takes on a much less inhibited, freer relationship to the oustide world than had been possible in the *Honeysuckle Bower*.

It had already been observed by contemporaries, and since then often repeated, that we continually encounter Helena Fourment's aspect in Rubens' later works, for example, as Bathsheba or Andromeda or as St. Cecilia (color plate 13, figs. 74 and 76). Nowhere,

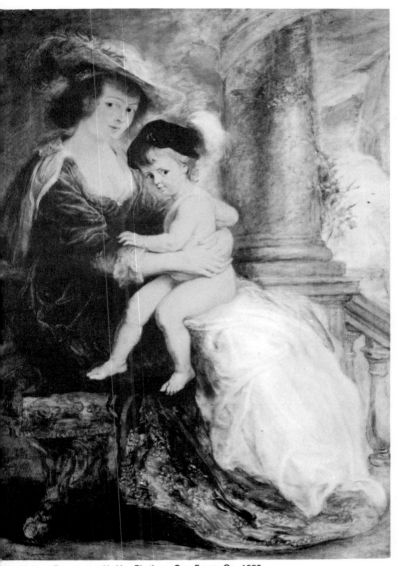

12 *Helena Fourment with Her Firstborn Son Frans.* Ca. 1635.

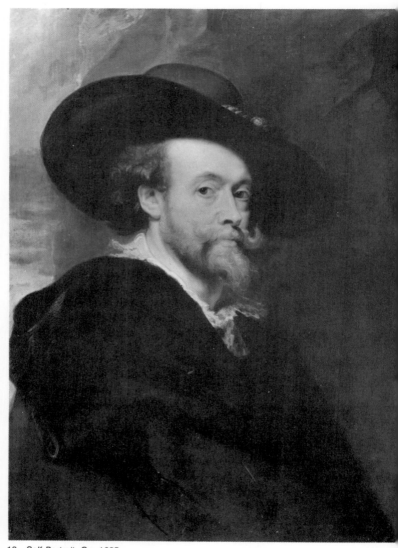

13 *Self-Portrait*. Ca. 1625.

however, does Rubens represent himself with Helena Fourment. None of the few illustrations which do show them together can be attributed to Rubens' own hand with certainty.

In contrast to Rembrandt, Rubens apparently had no strong need to exemplify the results of self-examination on canvas in the form of self-portraits. The relatively few self-portraits of Rubens were generated in part by external causes. The Prince of Wales and later King Charles I "entreated me so urgently for a portrait of myself that I could not refuse. Though it did not seem proper to me to send a portrait of myself to a prince of his status, he did, in the end, overcome my humility." On January 10, 1625, Rubens thus explained the origin of the self-portrait, which is still located in Windsor Castle (fig. 13).

None of Rubens' self-portraits illustrates his occupation. He did not portray himself with a brush or in his studio, as had other almost equally prominent painters such as Poussin or Velázquez. Rubens was quite familiar with this possibility. The self-portrait of Lucas van Leyden in Braunschweig, which Rubens copied from a ca. 1630 engraving (fig. 14), displays the painter's tools as well as a banderole extolling fame as toil's reward. Neither the costume nor physiognomy attempt to conceal the artisan. The only common element between Rubens' self-portrait at Windsor (fig. 13) and the van Leyden portrait is the sideward glance out of the picture, the sole indication that we are dealing with a self-portrait. As though accommodating a spotlight, the brim of the hat is tilted upward to expose the face, from which his gaze hesitantly confronts the public's interest. Rubens presents himself to the prince, with whom he would also personally conduct diplomatic negotiations six years later, more as a listener, a trustworthy partner in conversation, than as a negotiator. Rubens sent slightly altered versions of this portrait to friends and also had Paulus Pontius make an engraving of it in a somewhat precious fashion (fig. 15). On the evidence of this self-portrait, which definitely bears traces of his dramatic staging, posterity willingly saw in Rubens' appearance the image of an artist who for once was self-assured and successful. A self-portrait of Rubens painted about five years later, now located in Florence, is less able to satisfy this need (fig. 16). The missing hat exposes the balding head and the huge ear to view. Above the upper torso, advancing powerfully because of the treatment of the robes, the

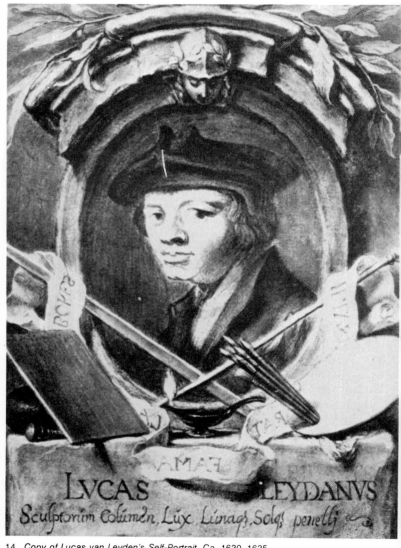

LVCAS LEYDANVS

Sculptorum Columen, Lúx Lúnaq̃, Solq̃ penelli

14 *Copy of Lucas van Leyden's Self-Portrait.* Ca. 1630–1635.

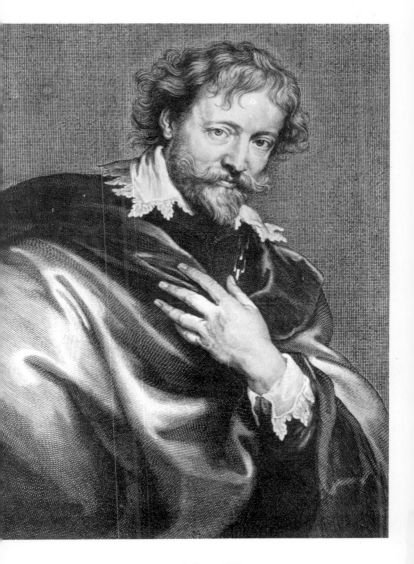

15 Paulus Pontius: *Portrait of Peter Paul Rubens*. 1626.

viewer encounters a gaze which coolly observes him at a great distance. In the last self-portrait he painted (fig. 17), Rubens once again brings into action all of the signs of dignity he had earned for himself. The column, beyond the pedestal of which Rubens' figure greatly extends, was long since a constitutive element of the aristocratic portrait. The sword is the one granted him as a knight of the English king. He presents himself half-length in the type of "state portrait" even Rubens usually reserved for the great figures of the world. The glove removed and casually left dangling is also an aristocratic pose practiced, for example, by Velázquez's infantes. A preliminary drawing for this self-portrait has been preserved (fig. 18) which can help us view the picture more exactly. In the drawing Rubens experiments with the reciprocal relationship between articles of clothing and a pregnant facial expression. The sword does not appear in the drawing; instead the torso is completely surrounded by a cloak, which fills the entire width of the paper in large, bulky blocks. The brim of the hat throws no shadow onto the forehead; instead it arches far back, and through its distortion at the nape of the neck, thrusts the face out of the picture. The collar does not constrict the face, but rather allows the robe to come nearly up to the rounded jaw, so that the gaze of the wide-open eyes can display its photographic sharpness. Such contrasts are of course toned down in finished paintings; yet it still remains evident that Rubens, along with the possession-hungry members of his middle-class station, held firmly onto what he had earned, but that he also, along with the intelligent, held onto critical doubt as a last resort for self-protection.

There is in itself no reason to play up his nobleman's rank to such a degree. Rubens was, to be sure, from time to time contemptuously labeled an artisan by members of the high nobility, and even his guild compatriots attacked his privilges. Nevertheless, the elevation of an artist to the nobility had been quite common since the fifteenth century and had intensified from the seventeenth century on. Rubens' oldest student, Deodat del Monte, for example, was also ennobled just two years after his mater by the Palatinate duke of Neuberg. Around the same year as Rubens, unimportant painters like Francart, Dervet, Serodoni, Sustermans, and Crescenzi were also ennobled, as were van Dyck, Hollar, and Gerbier. The number of artists granted a noble status had increased by leaps and bounds since

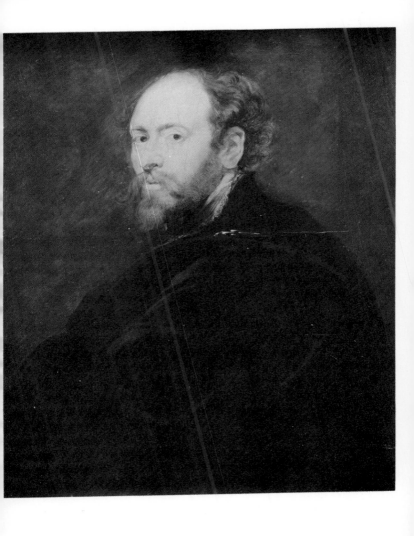

16 *Self-Portrait*. Ca. 1628.

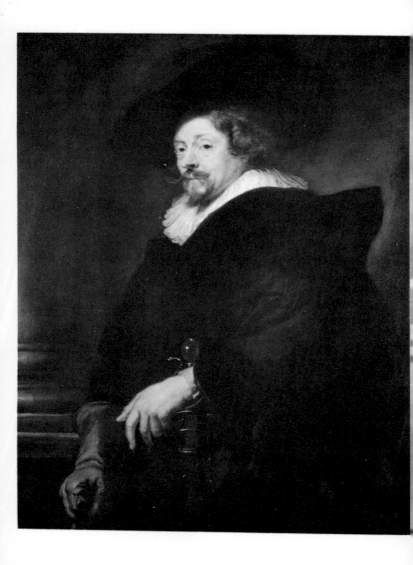

17 *Self-Portrait.* Ca. 1636.

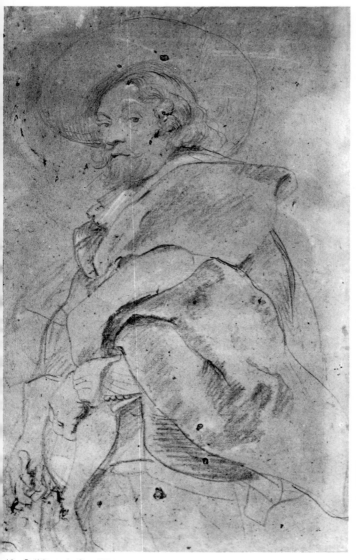

18 *Self-Portrait*. Ca. 1634.

the second half of the sixteenth century, reflecting the growing significance which came to the artist in traffic between the courts. As a general rule, the nobleman's rank meant exemption from civil and guild taxation and was thus an important advantage. Otherwise, there is no reason to make an especially big issue of Rubens' social position. What was special about Rubens is, however, that few others of his station were able to establish a similar material foundation. Thanks to a superbly organized studio, which became more and more productive, Rubens was able to amass, uninterruptedly, property and houses in a city which, in contrast to its heyday around 1560, had lost 50 percent of its population. In July 1627 alone, Rubens bought no less than six houses. In May 1635 he purchased the Castle of Steen (color plate 20), for which it was necessary to obtain the lordship of Brabant's permission, since numerous privileges were attached to the ownership. Rubens could now call himself "Lord of Steen." Around 1618 Rubens still said about himself that "he was not a prince and had to earn his living by means of the labor of his hands." Ten years later he, like some of his other middle-class peers who knew how to take advantage of the opportunities for advancement afforded by the courts, had well exceeded the limits of a working-class background.

Over the years Rubens had arranged his house in Antwerp (fig. 19) so that he could receive there his high-placed and royal clients. The house does not have a facade facing out onto the street; the architectural features are first revealed inside the inner courtyard. There the living quarters retain their old Flemish character. The studio wing across from them displays a decor of Italian origin. A triple-arched portico joins the ornate sandstone facade with the stark brick construction. At the same time, the portico separates the courtyard, which served as the house's center of activity, from the garden, in which a pavilion, arcades, and mythological statues provided a private recreation area. The fundamental idea behind this layout is the reciprocal contrast between *publice et privatim*, since private dwelling and representative studio, familial and professional sphere, workshop courtyard and formal garden clearly confront one another. The plan for statuary, about which we are indeed insufficiently informed, also seems to paraphrase this basic idea. The portico bore statues of Minerva, the goddess of science and the arts, and Mercury, the god of businessmen and diplomats, which faced into the court-

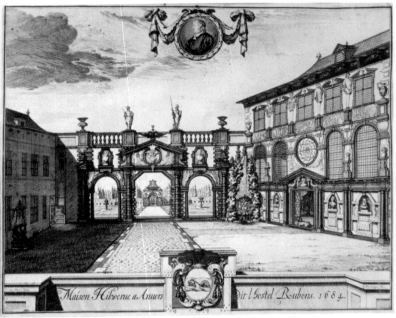

19 Jacques Harrewijn after J. van Croes: *View of the Courtyard at Rubens' House.*
1684.

yard (cf. p. 183 ff.); on two inscribed tablets trust in God and peace
of mind are extolled to the visitor. Yet behind this portico lies the
realm of arcades and fountains in which statues of Ceres and,
perhaps, of Bacchus, Venus, or Hercules as well set the tone. On the
facade of the studio wing, both domains seem to blend into one
another: the lower region displayed, interchangeably, nature gods
(Silenus, satyrs, and Faunus) and "culture gods" (Plato, Socrates,
and perhaps, Seneca, Sophocles, and Marcus Aurelius); the upper
story, above Hermes, displayed the Olympian gods Mars, Juno,
Jupiter, and Vesta. On the frieze between the stories, frescoes of
historical images and scenes out of mythology after Rubensian
paintings were displayed. The reciprocal relationship between art
and nature seems to have been the leitmotif of this colorful plan.
Interior and exterior, private realm and public, nature and art are at

29

once differentiated and interrelated. Only in the last decade of his life, after Rubens had withdrawn from politics and was summering in the country at the Castle of Steen, does it appear that the artfully balanced system of this relationship became problematic for him. During this time the self-portrait in chalk (fig. 20) was executed, which is perhaps best characterized by the statement from Tacitus that Rubens applied to himself: "Destiny and I have become mutually acquainted."

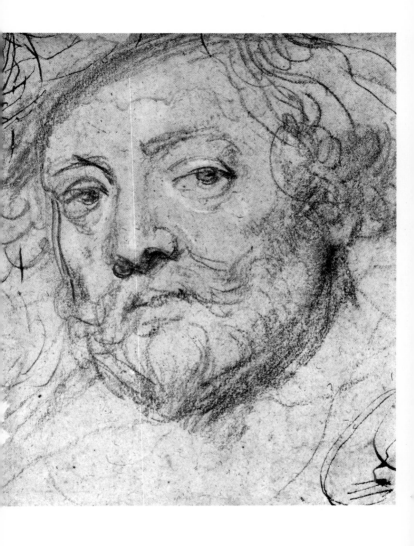

20 *Self-Portrait*. Ca. 1635 – 1640.

II. THE HUMANISTIC AND ECCLESIASTIC SPHERES

Around 1612, thus approximately three years after the *Honeysuckle Bower*, Rubens sought to establish his position as a humanist in a group portrait now to be found in the Pitti Palace in Florence (fig. 21). It is likely that the death in August 1611 of his highly educated brother Philip provided the motive for the picture's creation. Philip had been the pupil of the renowned and influential Justus Lipsius, who had striven for a revival of Stoic philosophy. The two deceased men are sitting at the back side of the table. To indicate that two of the figures represented are no longer alive, two closed tulips are set inside the vase situated in a niche in the wall. On the right side of the table is seated another pupil of Lipsius, Jan Wowerius. Rubens placed himself on the left side. The picture is a memorial as well as a programmatic painting.

In both form and content it is arranged antithetically. Within the somewhat restricted space, two distinct points of view are assumed. The heads, grouped in pairs, are set against each other above and below the diagonals of the picture. Wowerius and Lipsius, who is following the thoughts of a text passage, are sitting with their books opened, in front of the closed wall housing a niche with the bust of the philosopher Seneca. Their thoughts seem to carry them past the viewer. Across from them the Rubens brothers, who have placed their folio volumes on the corner of the table, are staring at the viewer. With the gesture of his hand, which intersects Lipsius' gesture in the center of the picture, Philip Rubens, his arm propped up, receives his teacher's train of thought, and with his gaze directs him back into the present. In life Philip had behaved in a similar fashion, since he had declined the succession to Lipsius' professorship

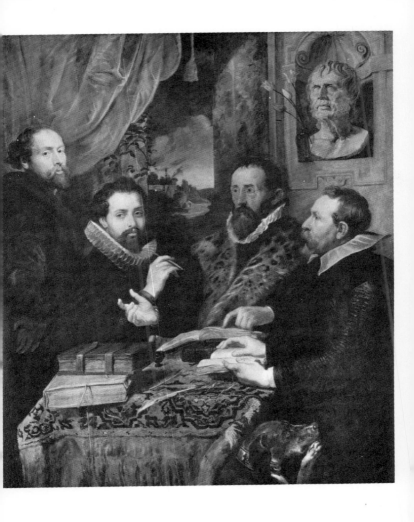

21 *Justus Lipsius and His Pupils.* Ca. 1611.

in order to serve as secretary to the city of his birth. Peter Paul Rubens is standing up; behind him a solemn curtain in front of the vine-entwined column calls attention to a landscape which represents the Palatine above the Forum in Rome, hence to a recollection of an old center of political import. Quiet, intensive scholarship and action founded in philosophy confront and permeate one another in the picture.

As he had already done in the *Honeysuckle Bower*, in this philosophers' portrait Rubens again enriched a personal documentary with programmatic images. And just as later on he no longer depicted himself in his images of marriage, he also no longer elucidated his humanistic notions with the help of such personal group portraits. Like the formulation of marriage in the *Honeysuckle Bower*, the formulation of this group portrait would also have a further effect, preeminently in Holland. Rubens himself, however, would espouse the fundamental ideas of the philosophers' portrait in all of those areas of life customarily served by the painter. At first these were the public and private realms of the citizen; soon thereafter, those of the rulers; then, the public domain of the Church. On the side, Rubens also produced pieces as stock on hand, rather than on commission, which he opportunely offered for sale or retained in his house; some of his early works were still listed in the register of his estate.

The altarpiece in Pommersfelden in which Rubens, presumably for a church in 'sHertogenbosch around 1615, had portrayed the death of St. Anthony (fig. 22) illustrates the dying moments of the hermit with reference to a painting of the death of the Virgin by Pieter Brueghel which Rubens owned. Because of the latter painting's direct influence, Rubens' picture becomes a representation of a teacher-pupil relationship. Contrary to written tradition, which reports that the dying Anthony had parts of his clothing sent to the patriachs Athanasius and St. Serapion, here they are themselves present to receive his robes.

With this emphasis on the transferral of spiritual inheritance, Rubens takes up thematically and pictorially the same subject that concerned him in the painting depicting the death of Seneca (fig. 23). As with St. Anthony, so also with Seneca, pupils and friends congregate around the dying master. Rubens faithfully fashioned the form of Seneca after a marble statue in Rome which he had drawn

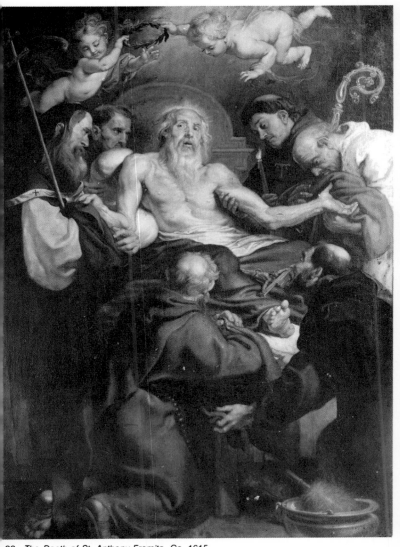

22 *The Death of St. Anthony Eremita.* Ca. 1615.

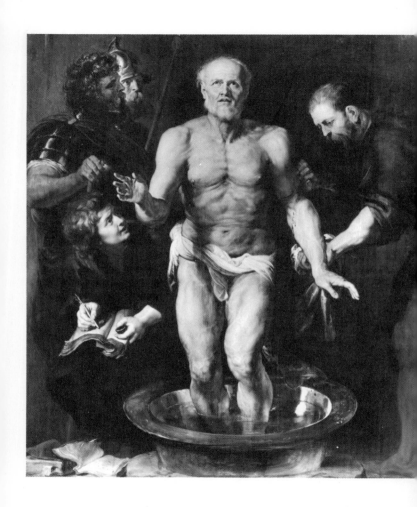

23 *The Dying Seneca.* Ca. 1611.

from several angles and which was regarded as a portrayal of Seneca dying. Rubens reshaped the plebeian head of this statue on the model of a marble bust which is also shown in the niche of the painting at the Pitti Palace (cf. fig. 21). To expand the lone statue into an historical painting, Rubens called upon the gruesome account in Tacitus' *Annals* (XV, 60-65). According to this report, Seneca had willingly chosen to die, because the tyranny of his former student Nero left him no alternative; he opened his veins and, after he had summoned a physician whom he had befriended, stepped into a basin of water to allow his blood to be spent more quickly. Seneca's suicide had been criticized by many humanists because it did not seem to them to be the proper means to combat tyranny. Rubens also explicitly turned against Stoic apathy and unengaged tranquility. It is not certain, however, that Rubens wanted to place Seneca's act before our eyes as a terrible lesson; it could also be intended as a somber confirmation of freedom in the middle of tyrannical caprice. Rubens shows Seneca from a full frontal view, his right hand interceding, as if in speech, into the onlooker's space so that the kneeling pupil can write down the master's last words in his notebook. His left arm, however, Seneca turns over to his physician friend, who expertly regulates the flow of blood. In the background Nero's soldiers, who watch over the proceedings, represent the power of the state against which this willful death was undertaken. This theme, which so radically poses the question of life's meaning under the conditions of political subjugation, was then repeatedly painted with reference to Rubens up until the French Revolution. Just shortly after the creation of the Munich picture, Jacob de Gheyn took up the theme (fig. 24). He gives Seneca the appearance of a wild chieftain who chooses the sacrificial death in a kind of confusion. It seems that he wanted to express a position in opposition to Rubens' painting of Seneca, which might have appeared to him as still too refined. The reaction indicates, nevertheless, that Rubens had addressed a question that touched upon the middle-class, humanistic understanding of the world.

The group of figures in the Seneca painting is found again, merely turned around in profile, in a church altarpiece, probably painted somewhat earlier (fig. 25), in which the relationship between spiritual activity and actuality is likewise examined.

In the church's inventory the picture is cited under the title *The*

24 Jacob de Gheyn: *The Dying Seneca*. Ca. 1611–1612.

Dispute of the Holy Sacrament. Rubens pictorializes this abstract subject in such a fashion that, in the foreground, the folio volumes are allowed to slip away while the church fathers vehemently discuss, ponder, and argue over the books. Thus, while they strive to become enlightened through the examination of concepts and words, in the background, above the altar, the actuality of the sacrament is already manifested through God's will. Above, a host of putti tries to transport the holy books into the actual space of the onlookers. If this painting treats the ecclesiastic and political question of defending the church of the sacraments against the Protestant "church of words," then its underlying theme could certainly be compared with the philosopher's painting in the Pitti Palace, where, incidentally, two folio volumes are also set aside in the picture's foreground (fig. 21).

In paintings from the seventeenth century, one can always count on such transferences from one realm of though and life to another. This is one of the means by which baroque painting filled the inherited formulations and concepts with reconstructable experiential values. The artistic forms also served this end. Their insertion was determined according to the purpose and intended effect of the picture. In 1611 Rubens sent two sketches on the same theme for the Antwerp Cathedral high altar to the chapter dean; they "had been painted in two entirely different fashions." Thus Rubens apparently had at his disposal various artistic possibilities which he could employ according to demand.

Hence, it is possible to appreciate the two well-known masterpieces Rubens executed between 1611 and 1614 in their very distinct modes of expression without immediately having to speak of a fundamental change in the artist's style (fig. 26, color plate 2). Both altar paintings are winged altarpieces, traditional Flemish triptychs painted on wood; their central panels are over four meters high and three wide. Rubens nevertheless chose to employ a completely different artistic language for each of these altarpieces: pathetic tones in the *Elevation of the Cross* (fig. 26), elegiac quiet in the *Descent from the Cross* (color plate 2). This choice not only was suggested by the subject matter but was also a reflection of the different contexts for which their effects were intended. Today both winged altarpieces hang in the transept of the Cathedral at Antwerp. Originally, however, the *Elevation of the Cross* (fig. 26) hung above the high altar

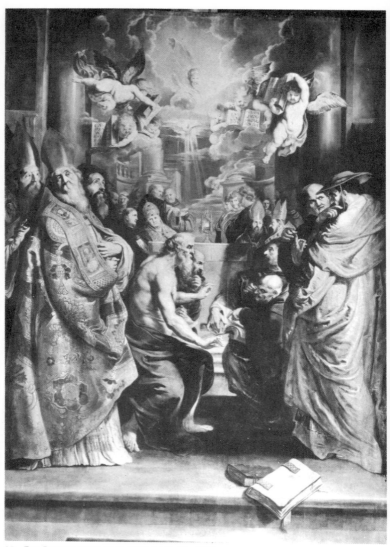

25 *The Dispute of the Holy Sacrament*. Ca. 1609.

of the Church of St. Walburga, located in the castle region near the harbor, while the *Descent from the Cross* (color plate 2) was designated for a side altar in front of one of the pillars in the cathedral's transept. As a high altarpiece the *Elevation of the Cross* had to fill one whole area of the church and therefore had above it a procession with God the Father and below it a predella, from which only one scene in Leipzig has been preserved. In contrast to this, the *Descent from the Cross* had been commissioned by a municipal corporation, for whom it was supposed to provide a meditative atmosphere within the spacious cathedral.

The *Elevation of the Cross* (fig. 26), unlike the *Descent from the Cross*, has a continuous context of events stretching across all three wings. This context concentrates on a single, total statement which pits the perpetrators and the victims of violence against one another: on the right wing the centurion vigorously realizes his power of command as he supervises the action from a charging horse. His violent movement is answered on the left wing by the helpless grieving and introverted sorrow of Mary, St. John, and a group of women. In the central panel the body of Christ, laid out and set in luminous relief in an attitude of long-suffering composure, forms a contrast to the Herculean display of strength of the bull-necked officers with their many-colored garments and leathery bundles of muscles. Because the officers' ground offers little room, they advance far forward and direct the stem of the cross out of the picture into the viewer's space. Unwittingly, they assist the graphic realization of the event of the crucifixion. In an oil sketch in keeping with the painting, Rubens had set the cross far back into the picture, as had Tintoretto in a wall painting in the Scuola di San Rocco, from which Rubens had also drawn other motifs. The decision to turn the cross into the space of the church in this dramatic fashion may have come in response to a woodcut by Baldung-Grien (fig. 27), in which Christ is turned full face toward the viewer. Rubens' version, however, adds a dynamic element which invites the comparison of the Roman officers' actions to the erection of a public triumphal monument. Around 1623 Rubens had himself copied the *Gemma Augustea* (fig. 28), which shows on its lower half the erection of such a triumphal monument (tropaion). Rubens also reformulated other elements in it for his *Elevation of the Cross*. Justus Lipsius, in a scholarly essay on the history of the cross, pointed out and described the parallels between

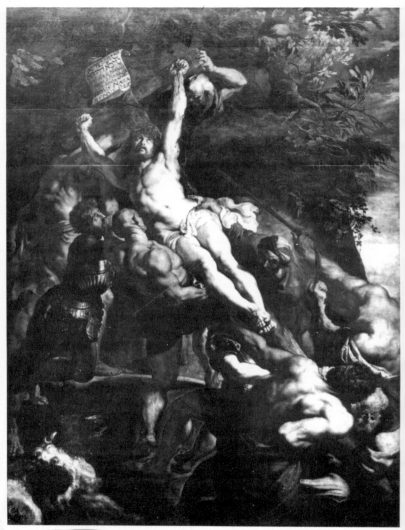

26 *The Elevation of the Cross* (middle panel of the triptych in Antwerp). 1610–1611.

27 Hans Baldung-Grien: *The Elevation of the Cross*. 1507. ➤

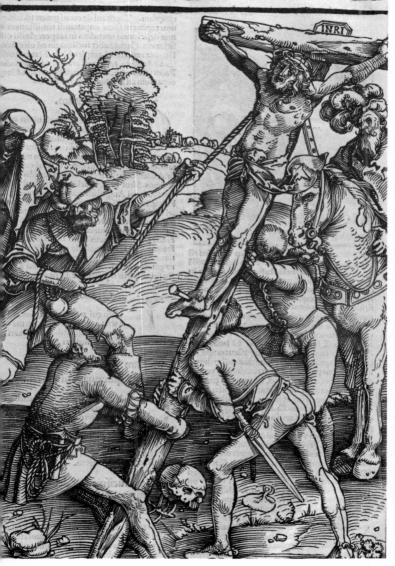

victory paintings and the cross as an instrument of punishment, how under Constantine the cross became a symbol of the state. While the officers in Rubens' *Elevation of the Cross* dispel this idea of victory, Christ himself offers the image of a passive sufferer. Elements from the Laocoön statue, which was at the time regarded as an *exemplum doloris*, a model of agony in motion, are incorporated in the upper torso. The fundamental concept behind the Seneca painting (fig. 23) is also present here: the pathos of human passion unfolding before the power of the state. Rubens reinforces this point still further by rendering Christ in an unusual way, hanging with his arms stretched upward. As early as 1600 the painter Geldorp, well aware of the corresponding Michelangelo drawings, had developed this form of portraying the crucifixion — a solitary Christ hanging on the cross — for the town hall in Cologne; Rubens, through his *Elevation of the Cross*, would then spread this style of crucifixion.

This long-suffering passivity emphasized in Rubens' treatment was criticized by a well-known Protestant theologian and Humanist, Georg Calixtus. A comment printed in the year 1640 in appendage to an edition of Justus Lipsius' treatise on the cross adds to the few known public opinions of Rubens' contemporaries on his art: "I remember once seeing a painting of the crucified Christ composed by the famous painter Peter Paul Rubens. As though he wanted to remedy a contradiction, he depicted the hands of Christ stretched upward above the torso; the hands were not outspread but placed together more, so that the body hung from them. But even so they did not give the impression of holding the body up. This of course also contradicts the views and convictions of all our ancestors." Calixtus was making a case for the contention that Christ stood on a footboard and thus could be imagined as having a dignified posture even on the Cross. Just as de Gheyn (fig. 24) only saw the central figure in Rubens' painting of Seneca, Calixtus was also unable to see that in the *Elevation of the Cross* Christ's dignity is revealed through his ability to suffer, which transcends official acts of violence.

The subject of the elevation of the cross had evidently never been portrayed before in Dutch altarpieces. Yet Rubens himself had already painted it once before in 1601 in Rome for his lord, Archduke Albert, who had ordered it. Even in Italy this was a new subject for an altarpiece. The depiction has been preserved in a copy in Grasse. The Church of St. Walpurga, the high altar of which had been

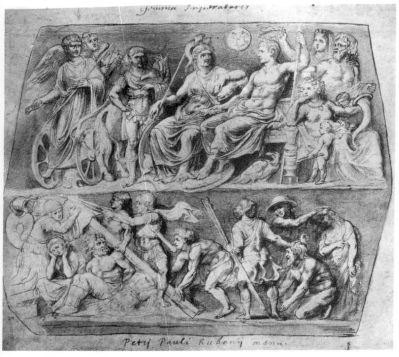

28 *The Gemma Augustea.* Ca. 1623.

designated to house the *Elevation of the Cross* now in Antwerp, was
also called the "castle church," because it was in the castle section of
Antwerp and was thus situated within the region of sovereign
immunity, at the time still surrounded by a wall. In 1610 the
directors of the church assembled to discuss the altar. When the
contract was closed with Rubens, Cornelis van der Geest, whom
Rubens later dubbed the project's "promoter," was also present. It is
conceivable, however, that van der Geest acted as the middleman for
the archduke's wishes. We know from a painting that Archduke
Albert visited van der Geest's collection and there also met with
Rubens. It might have been at Albert's request that his newly
appointed court painter made use in Amsterdam of the innovative

altarpiece theme he had come up with for him ten years before in Rome. The basic theme of Rubens' painting coincided completely with the aims of the two heads of state. Up until then the Spaniards in the Netherlands had relied above all else on their due right to a monopoly on state power. Against resistance from Madrid, the governors Albert and Isabella had effected an armistice with the northern Dutch provinces in 1609, and it was one of the new central government's principal goals to turn Antwerp, prostrated since the blockade of the Schelde, into an ecclesiastical and theological center of counterreformation culture. In his altarpiece Rubens rendered this idea of an *ecclesia triumphans* in such a manner that the myrmidons of worldly power assist in the birth of a new Christian understanding of the world.

The *Descent from the Cross* (color plate 2) differs from *The Elevation of the Cross*, since it was commissioned by a municipal shooting club, for whom it was to function as both a focus of devotion and a place to gather in the cathedral. Unlike the *Elevation of the Cross*, the *Descent from the Cross* had long since been a fixture on many altarpieces of Dutch churches and chapels. Rubens borrowed an important aspect of its depiction from this native tradition. In Italian versions of this theme, some details of which were compulsory for Rubens, the scene as a whole is separated into two poles: both to one side of and further away from the cross, from which Christ's body is being removed, the disciples and women gather around the unconscious and prostrated Virgin. In contrast to this, it had been common in the Netherlands since Dirc Bouts to gather Mary and her companions around the body of Christ after it had been removed from the cross — in other words, to unify the course of events. An elegiac nighttime atmosphere was also used from time to time, even as Rubens employed, to underscore this effect.

This is where Rubens comes in, since, with the revival of the Mary Magdelene cult in mind, he allows all of the action to revolve around this saint. If, as is often said, the sacrament of the eucharist is supposed to be illustrated on this side altar by the presentation of the body of Christ like a host at communion, then it should certainly be recognized that this liturgical meaning is mediated by the events and actions clearly unfolding in each individual scene. After Joseph of Arimathea had claimed Jesus' body from Pilate, he went with a few friends to Golgotha in the late hours of the night in order to take the

body down from the cross. According to Rubens, except for John, each of the men brought along a ladder, since there are no less than four ladders leaning against the crude base of the cross. First, the inscribed plaque and Jesus' crown of thorns were removed and placed in a plate which had been brought along. Then the nails were removed from the feet and one hand. After this a white cloth could be guided along underneath the body and the corners distributed among the men so that, in any event, the body could be securely lowered. The figure who removed the upper left nail lowered the shoulder and arm down to Joseph of Arimathea. The body sagged to the right, and John tried to hold it up by bracing his right leg against the ladder. Because the last nail was removed at the proper time and, above, one of the men had caught the cloth between his teeth, keeping his right hand free to carefully lower it down, the body was able to slide smoothly onto John's breast.

In a book on Christ's Passion, in which he attempted to render the holy event accessible as a living experience in the life of a believer, a leading Jesuit in Antwerp, Carolus Scribanus, described the *Descent from the Cross* as a paragon of friendship: Jesus had been abandoned in the hour of his death by all of those who had shouted hosannas or been healed by Him, including even His disciples. Only the wealthy Joseph of Arimathea dared to ask for the possession of the body from Pilate and to take it away with a couple of friends, thus demonstrating that prosperous friends who are not bound by material motivations are more likely to come through in times of emergency. This interpretation of the *Descent from the Cross* as a triumph of friendship and solidarity lent a significance to Rubens' altarpiece for the shooting club similar to that expressed simultaneously in the philosophers' painting (fig. 21) and in the painting of Seneca's death (fig. 23). The figures straining away from each other while disposing of Christ's body in the *Elevation of the Cross* (fig. 26) contrast with the friends in the *Descent from the Cross* (color plate 2) who silently retrieve the body. The strained display of strength in response to a command in the former picture contrasts with the quiet activity guided here by a kind of understanding revealed by the very handholds. Rubens no doubt wanted to convey to the club, which had long since outgrown its military function, a new concept of community, that *sensus communis* he so often talked about with his humanistic friends. That Rubens did not reuse this theme for other paintings on the same

47

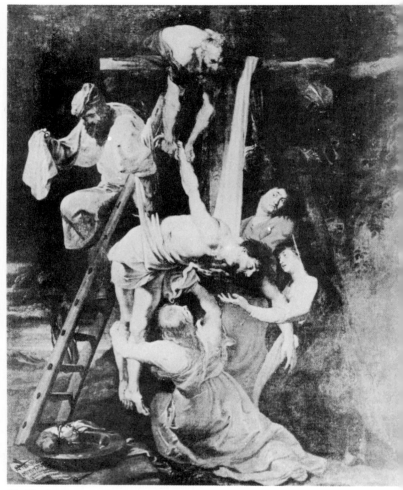

29 *The Descent from the Cross.* Ca. 1612.

30 Hans Baldung-Grien: *The Descent from the Cross.* Ca. 1505.→

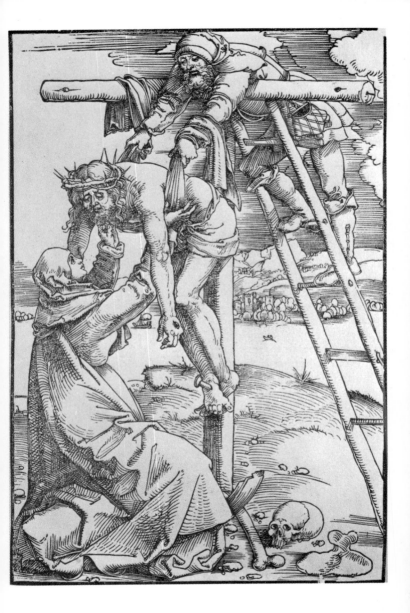

subject executed in his studio also demonstrates that he conceived this *Descent from the Cross* with this particular group in mind. In the *Descent from the Cross* which he was painting at the same time for the Saint Omer cathedral, the body of Christ is lowered precipitously in the cloth (fig. 29). In this example he does not address the message of community, but rather brings out a dramatic element reminiscent of the stirring graphic representations (fig. 30) of the pre-Reformation period.

As exactly as Rubens could calculate such desired effects and as essential as their consideration is for our present understanding, Rubens nevertheless always maintained that a painting had to be more than the sum of its exterior stipulations, which he regarded as external constraints (*necessità*). In 1607 Rubens commended to Duke Vincenzo Gonzaga a previously rejected altarpiece by Caravaggio and justified his defense of it with the astounding argument, "The picture is in no wise discredited because it has been rejected by the monks for whom it was designated." This statement imputes qualities to a painting which allow the work to remain untouched by all topical stipulations of purpose. Rubens opportunely commended a painting portraying Abraham and Hagar with the justification that the subject matter was "quite unusual, neither sacred nor profane, though it is drawn from the Scriptures." In 1619 Rubens was also able to justify the distribution among the protestant Dutch of engravings after his paintings for the Jesuit church in Antwerp, because "the subjects treated are in no ways political, are very simple and contain no ambiguities or secrets." This faith in the unique value of the artistic form through which the aims of its contents can be neutralized entitles us to regard Rubens' world of forms as a medium which addresses its own particular intentions.

Rubens was expanding on impulses from Italy which dedicated painting anew to the truths of experience and nature. Using these as a point of departure, the principal goal of his formal language became the presentation of the painting's reality as a constitutive element of the viewer's reality. The compositions are arranged so that they open themselves up to the viewer and allow him to participate directly in the action of the picture. In the *Honeysuckle Bower* (color plate 1) and in the *Descent from the Cross* (color plate 2), the action is revealed through an oval-shaped organization in order to facilitate a view into a more intimate context of events. The circle of figures can remain

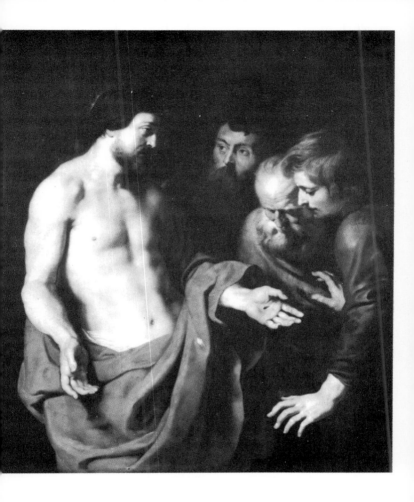

31 *The Doubting Thomas. Christ Appearing to Thomas, Paul, and Peter* (middle
panel of the triptych). Ca. 1613–1615.

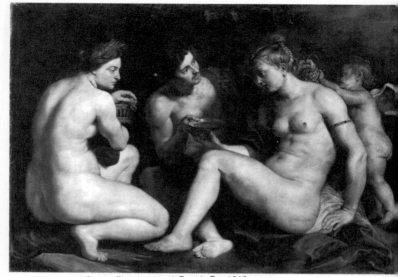

32 *Venus, Ceres, Bacchus, and Cupid.* Ca. 1613.

opened toward the viewer. On the epitaph for Rockox, Antwerp's
mayor (fig. 31), Christ confronts not only the unbelieving Thomas;
rather, in opposition to all tradition on the picture's theme, Peter
and Paul are also associated with Him. The simple fact that Christ is
looking primarily at Thomas allows the viewer to include himself in
the circle of witnesses.

The painting in Cassel showing Venus, Cupid, Bacchus, and
Ceres (fig. 32) is one of a small group of pictures of these years in
which Rubens strikes an exceptionally cool and restrained tone.
Since he signed these paintings — otherwise a very rare practice — it
can be assumed that Rubens wanted to point out explicitly their
"classicist" habit as part of his stock repertoire. From a thematic
point of view, however, the quiet circle of figures should particularly
attest to the fact that love (Venus) without nourishment (Ceres) and
drink (Bacchus) grows cold. This affirmation of the emotion of love
also comes through, then, in the openness of the composition; the
circle of seated figures seems more to invite the viewer in, rather than
to close him out. In other paintings, as in the *Seneca* (fig. 23) or in the

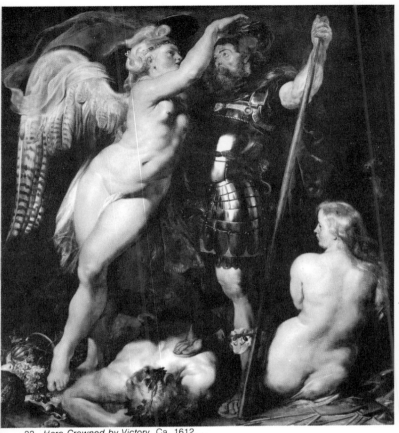

33 *Hero Crowned by Victory*. Ca. 1612.

Elevation of the Cross (fig. 26), for example, the groups and figures gesticulate into the viewer's space. In the philosophers' picture (fig. 21) the action is only resolved when the viewer chooses among the possible alternatives. Rubens also laid out the *Hero Crowned by Victory* (fig. 33) in an antithetical manner. The champion of virtue appearing in metallic armor has conquered and tread upon debauchery and intemperance. In reward for his deed he receives the wreath from a

53

34 *Hercules Drunk*. Ca. 1612.

naked Victoria, who amorously approaches him. This suspenseful relationship was also extended between paintings, insofar as *Hercules Drunk* (fig. 34) was associated with the *Hero Crowned by Victory* as a contrast piece. If the hero in this former picture is confined inside virtue's protective armor, then Hercules, the prototype of virtue's athlete (cf. fig. 55 upper left), in the latter picture displays his powerful body to the viewer and lets it be known in his leering expression that his predicament is distressing.

In order to push the action out of the picture and to activate its surface, Rubens has the figures appearing in the foremost plane of the image, where they are placed more on top of one another and pressed together, than behind one another. In a particularly striking man-

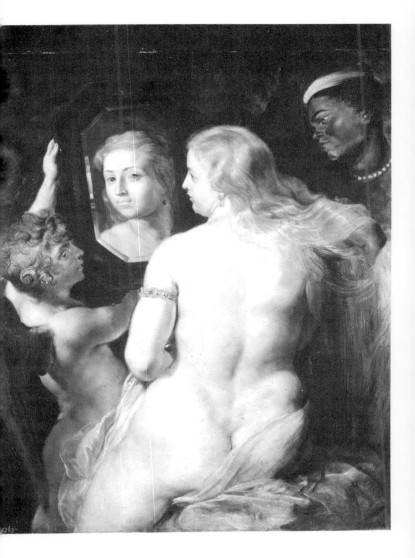

35 *The Toilet of Venus*. Ca. 1613–1615.

36 *Christ Laid in the Tomb,* after Caravaggio. Ca. 1613–1615.

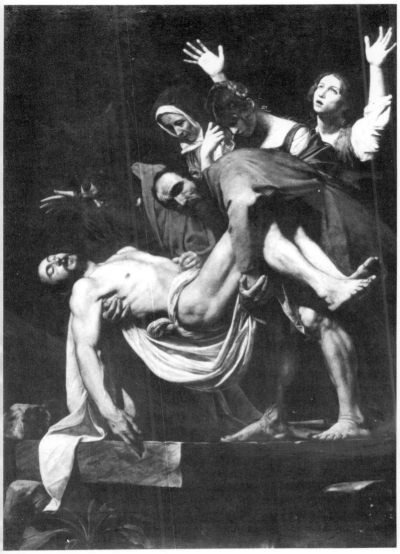

37 Caravaggio: *Christ Laid in the Tomb*. 1602–1604.

ner, the landscape in the *Elevation of the Cross* (fig. 26) towers upward to a background scene which constricts the proceedings' room for play to such a degree that it of necessity presses outward beyond the frame of the picture. In the *Honeysuckle Bower* (color plate 1) it is the bower and in the *Seneca* (fig. 23), the *Elevation of the Cross* (color plate 2), and Rockox's epitaph (fig. 31) it is the dark background which cause the figures, as if in relief, to advance forward. In the *Toilet of Venus* (fig. 35), the exclusion of all interior motion is a clearly developed, conscious effect. In the *Hero Crowned by Victory* (fig. 33), now in Munich, the naked female figure facing inward signifies debauchery overcome. The idea of having Venus, during her toilet, looking into a mirror which a cupid is holding up to her Rubens owes to Titian's circle. Whereas in prototypes of this image, Venus looks into the mirror in order to see herself, Rubens makes use of the mirror effect so that the viewer is directly confronted with Venus' gaze and face. Whatever contrives to create a depth of image is again propelled out of the picture by the inclusion of the mirror.

The neutralization and activation of the depth of field and the breaking open of the picture's frontal border convey an undisputed central importance to the human figures. They are exaggerated, vitalized Michelangelo figures. They do not appear in Rubens' works as academically constructed, formally premolded models; instead the figures' contours are so vitalized by their expansion and stretching that they seem to outgrow themselves. As a result of this figurative style Rubens' pictures do no appear as ideas thrown into relief, but rather as sources of energy. Within the contour of the figure the flesh tone emerges out of dark (for the most part brown), cool, base shadings as a thick texture of red, blue, and yellow hues against a light emanating from the viewer's space. In the flesh areas the colors, layered in glazes, work out the body's detail, whereas in the robe areas, where they can be thoroughly smoothed down, the colors only indicate. Because they appear as pure natural colors scattered over the picture in small mottled patches without closer relationship to one another, the figures retain an unequivocal preeminence. It is remarkable that figures in Rubens which are so thoroughly oriented toward external response and "persuasion" almost totally forgo extensive rhetorical gestures. When Rubens copied Caravaggio's *Entombment* around 1613, he toned down the expressive gestures of the original (figs. 36, 37). In the philosophers' picture (fig. 21) the gestures are concise and economically determined by the postures

and counterpostures. Even Seneca (fig. 23) does not display an excess of emotion, and the motions of his hands, as is true for other Rubensian figures out of these years, stay contained within the body's or the group's circumference. The gestures do not entreat; instead they argue.

This Rubensian type of image which addresses the viewer renders the picture's impact dependent on the viewer's capacity to respond. The picture is not a self-contained sphere in which all the possibilities of an idea are already revealed; it is rather a sphere of action which awaits a reverberation and a reply. In these first years in Antwerp Rubens evidently intended his painting to play an active role in raising the consciousness of his contemporaries.

At this point it is difficult to explain the process by which, since about 1615, Rubens step-by-step took back the narrative effects and purposes intended by his pictorial forms. More and more Rubens came to understand a representation as a world complete unto itself which was no longer capable of complementing the outside world. This world could still be perceived and surveyed, but it no longer provoked nor did it compel; instead, it demonstrated.

Half-figure pictures showing only part of a scene now became rarer. If we compare the center picutre of the Rockox epitaph (fig. 31) with the picture dating from around 1618 in which Christ appears before the repentant sinners (color plate 3), we observe canvases still densely filled with figures. In the former, however, the group is arranged so that the viewer is addressed and drawn into the picture; in the latter, on the other hand, the central figures are set in diagonally, turned completely toward each other in profile. The companions — the theif, David, and Peter — shift the resonance onto the proceedings taking place in the background as if in a niche. Christ and Mary Magadalene are drawn closely together, and the outlines of their body contours flow into one another. The contrast of yellow-gold and red in their robes develops a dazzling balance of its own, so that the antithetical juxtaposition is now resolved internally, rather than outside of the picture.

Just as the *Boy Playing with Bird* (fig. 7) keeps quite to himself, in the *Madonna Surrounded by Garland and Boy Angels* (fig. 8) the putti are trying their hardest to block off from the outer world the area of the Madonna's portrait from which the Christ child still looks out at the view.

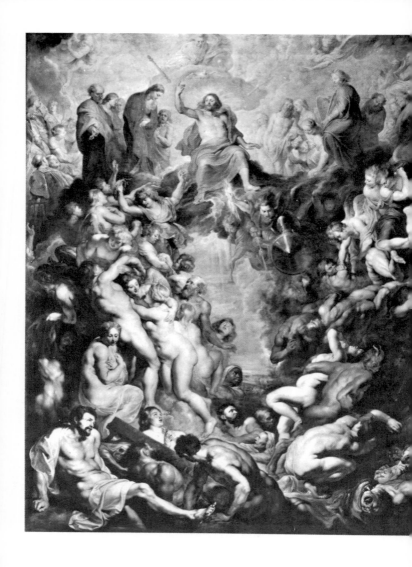

38 The Large *Last Judgment*. Ca. 1616.

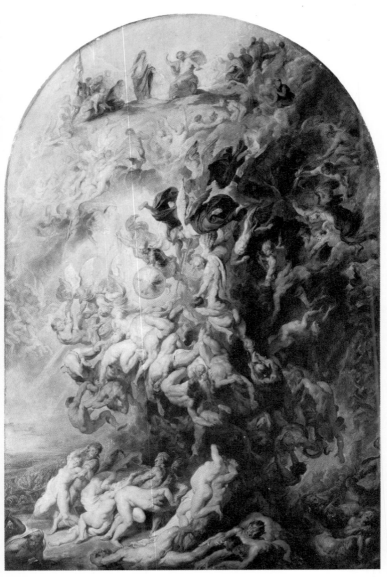

39 The Small *Last Judgment* (cf. color plate 4). Ca. 1620.

Here Rubens crowds the image field with tightly composed figures which are complete unto themselves. In the large *Last Judgment* (fig. 38), the multitude of bodies is arranged in a triangle standing on its apex. Beneath them, along the frame of the painting, the way is blocked by a crossbar and the vanquished damned. On the right leg of the triangle, the condemned struggling upward are hurled back, whereas, along the left leg, the blessed are led upward into the domain of the throne of judgment. This area is set into relief and graduates backward spatially. The colors also become more subtle, from the solid, gray-brown flesh tone of the human crossbar in the foreground, through the pale flesh tone of the blessed, to the pure harmony of color in the heavenly region. Whereas Rubens does not adopt from Frans Floris' Viennese representation of divine justice the idea of having the condemned tumbling out of the picture, he does accept the idea of moving the heavenly parapet back so that, unlike in Michelangelo's *Last Judgment*, the judicial power of the Redeemer now barely reaches the viewer. In the small *Last Judgment*, too (fig. 39, color plate 4), the Supreme Judge is set back into the distance. As the main event, Rubens stages the pursuit of the damned, who plunge into hell in a confused mass as though drawn by lead weights.

Like the large *Last Judgment*, the painting of *Castor and Pollux Seizing the Daughters of Leucippus* (color plate 5) exhibits a monumental, closed compositional form. Above the horizontal of the landscape set far back into the picture, the group of figures rises up in the form of a rhombus standing on a point. The rape of the royal princesses Hilaeira and Phoibe by the Dioscuri Castor and Pollux had evidently never been represented before. The eighteenth century first learned their names after Winckelmann had pointed them out in a similar scene on a Roman sarcophagus. Rubens' picture was considered an allegory of marriage, but it might also be a treatment of a political allegory, since, according to information from the Humanist Gevartius, the Dioscuri were also considered to be the patron gods of seafarers. Perhaps the two are here abducting the Spanish king's "daughters," the two Dutch provinces of their port cities Antwerp and Amsterdam, to more fortunate domains. It might also be significant that the female figure held up in the center of the painting is modeled after Leda, who, according to mythology, is the mother of the Dioscuri. The outcome of the seizure is, to be

sure, fully apparent, but does not constitute an appeal outward. The action turns on its own axis and lays full claim to the figures. These figures are no longer self-contained, but extroverted. The arms and legs, heads and feet, even those of the horses, establish their independence from the body with detached motions expressing a radiant pathos. The colors of the robes — yellow-gold, green, and red — also become independent from the objects and create a classical harmony that is aesthetically perceptible above and beyond the context of the figures.

The *Perseus and Andromeda* in Berlin (fig. 40) is also a political allegory, since it was common to portray a city, for example, as Andromeda being freed from some form of bondage by a king or general who appears as Perseus. This is not a description, as in the *Leucippus*, of a dramatic moment which brings the figures to a climax, but rather a subtly nuanced psychological representation — note the placement of the heads on the same level — of the text of Ovid's *Metamorphoses* (IV, 670 ff.). The rock ledge along the lower edge of the painting against which the seawaves beat pulls the scene away from the viewer. Pegasus, the horse on which Perseus killed the dragon set to keep watch over Andromeda, even turns his backside to the viewer. Around the pearly-fleshed, extremely sensitive-looking Andromeda, the putti also carefully create a protective zone of sorts within which Perseus can unfetter her with great caution. Meanwhile, his cloak is blown back, seemingly without reason, rising up into the picture's center as a free, bright-red main accent of color.

After 1615 Rubens developed in his paintings hermetic circumstantial relationships which are perceptible, though no longer capable of being completed by the viewer. The pictorial world lays complete claim to the figures; their postures and gestures are integrated into the action so that they no longer have any energy left over for external relationships. They have fluid, relaxed outlines and a light, sensitive flesh tone so that the surrounding colors can be reflected from them. The space between the figures corresponds to an opening up of the depth of field, which, as landscape, allows the figures to unfold within the picture.

Rubens' first characteristic landscape paintings fall into this period. In the representation of the *Prodigal Son* among the swine (fig. 41, color plate 8), an animal stall opens up the surface of the picture so that the eye is led from level to level past horses, cows,

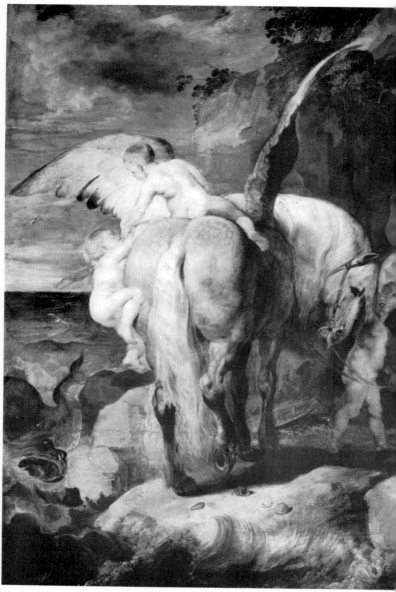

40 *Perseus and Andromeda*. Ca. 1619–1620.

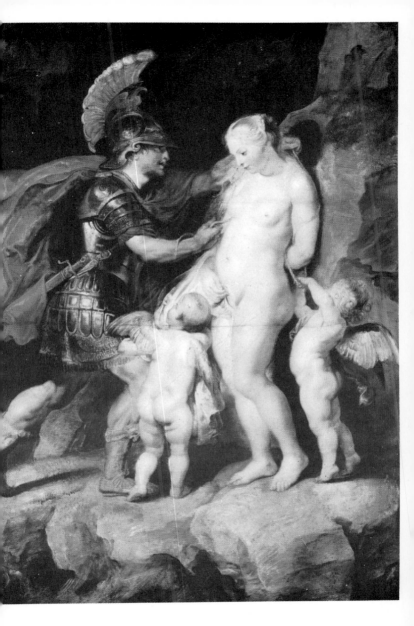

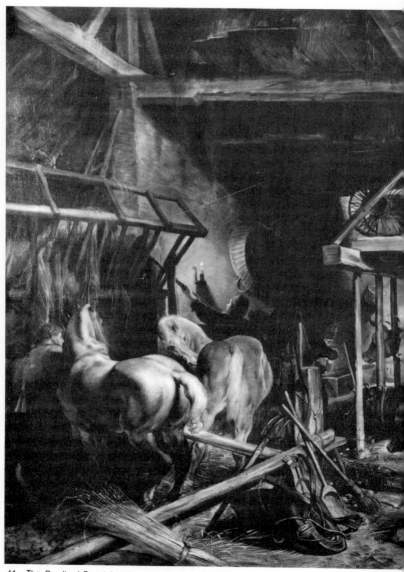

41　*The Prodigal Son* (cf. color plate 8). Ca. 1617–1618.

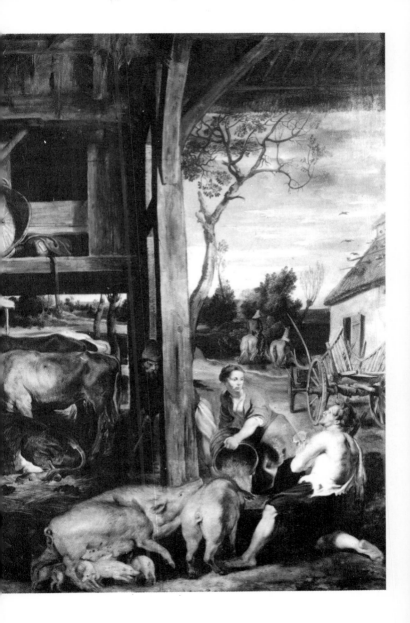

feeding troughs, and baskets into the distance to an evening horizon, toward which, in the back right, also trots a group of horses. The prodigal son's situation — Rubens copied it from a Dürer engraving in which the figures were set in relief — here remains of marginal importance.

While in the painting of the *Prodigal Son* guidelines are still offered which lead the eye into the depth of the picture, the *Landscape with Milkmaid and Cows* (fig. 42) must be viewed from the outisde as a self-enclosed world. The creatures inhabiting this self-contained, tranquil space all evince motion toward the interior of the scene; all the cows, for example, are turning away from the viewer as though frightened. Even the milk pail in the foreground has its "back" turned on the viewer, and the stream which in the middle ground broadens into a lake is hidden on the right by thick underbrush.

This disclosure of circumstantial relationships capable of resolving everything in themselves can also include the dramatic proceedings. The *Battle of the Amazons* (color plates 6 and 7) was a cabinet picture that Rubens painted for his patron, van der Geest. We know from painted views of his collection that van der Geest had hung it by a window where a curtain could protect it from the sun's rays. For a connoisseur of art the picture contains numerous enticing morsels. On the bridge above, the equestrian battle over the standard is a quote from Leonardo's *Battle of Anghiari*, which has actually been best handed down to us via Rubens' copies. Reminiscences of ancient sarcophagi are scattered in the intricate action; recollections of other battle scenes are also reworked in it, such as those offered by Titian in the *Battle of Cadore* or Giulio Romano and Lastmann in the *Battle of Constantine against Maxentius*. The battle on the Thermodon River (which in the seventeenth century was still believed to be within the territory of the Amazons), where the Athenians had beaten back the Amazons, was portrayed quite often on ancient sarcophagi. In an early drawing illustrating an Amazon battle, Rubens still located it in open country. Now, approximately twenty years later, the arching bridge broadly extending over the river has become the nexus of the battle's action. Since the Amazons' flight has come to a standstill, the bridge becomes the stage for panic fear and fierce individual struggles. On the left-hand side of the bridge the Amazon queen Antiope, who is looking over at Theseus, is restrained and her life threatened. The struggle for the standard, the climax of the battle,

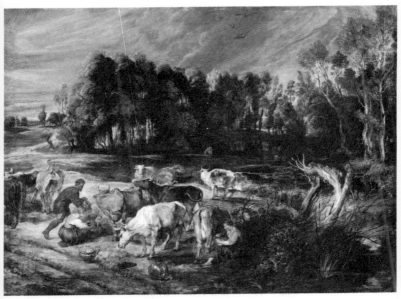

42 *Landscape with Cows and Milkmaid*. Ca. 1618–1620.

unfolds above the highest point of the bridge's arch; here lies a
corpse, the head of which an Amazon holds triumphantly aloft in the
background to the right. An Anthenian has seized a corner of the
standard, while its bearer tries with acrobatic agility to keep hold of
it from his rearing horse.

Wilhelm Heinse, who has left behind an impessive description of
this Rubens painting, among others, feels that this picture cannot be
enjoyed unless "one has descended into the furthermost nature." It
seems that this statement can be taken literally, since the picture
illustrates the closest fusion of figurative and natural factors. In the
upper half of the picture, above the bridge, the chain of bodies is
thrown into relief from behind by a sky in which both clouds and the
billowing smoke of the burning Amazon capital blend together. In
the lower half of the picture, below the broadly expanding arch of the
bridge, the river's current, catching the bodies falling from its banks
and the bridge, is whipped up into a convex counter-arch. It hurls

them living or dead toward the horizon deep within the picture. All the vehement action stemming solely from the figures is, in the lower half of hte painting, subsumed and swallowed by the picture's internal forces — in this case by Nature's current.

The *St. Sebastian* (fig. 43) in Berlin is dated, according to varying research, from either ca. 1612 or ca. 1617. The softly modeled corporeal apparition projected outward from the deep horizon and set in a bright light might suggest an earlier dating. The figure bound to a mighty tree, unable even to gesture — a sentiment so clearly echoed by the landscape — might also appear bound within the image in the later style. This the reader can decide for himself.

The endeavor to lead the self-contained energy of the forms into an interior connection with the painting's order also effects the expressive content and can convey a new meaning to preexisting themes.

For the newly built Jesuit Church, the architeccture of which he also helped design, Rubens supplied the pictorial furnishings for both the choir area and the ceilings at the side of the galleries. He produced the ceiling paintings (fig. 44) on a Venetian model of such strong foreshortening that they appear to be located beyond the space of the church. He had already begun the paintings for the high altar around 1617. There the deeds of the two most important members of the order were supposed to be illustrated alternatively. The founder of the order, Ignatius Loyola, was supposed to represent the European sphere of influence and the church-internal aspect of reform; Francis Xavier, as a missionary in China, India, and Japan, was supposed to represent the world perspective or the external political mission of the order with respect to the conversion of heathens. Neither member of the order had been canonized at the time and therefore was as yet qualified, in the strictest sense, to grace a high altar. Yet ultimately such demonstrative acts were also intended to spur on their canonization in Rome — which occurred in 1622. The two large paintings were supposed to be exchanged from time to time so that each could be placed alone above the high altar for part of the year. This was a new form of altar didactics which the Jesuits had introduced and also practiced elsewhere, in Ghent, Brussels, and Cologne, for example. In order to give the believers the opportunity to view both pictures simultaneously, however, the Jesuits displayed on the columns in front of the choir the sketches of both, which Rubens had prepared before starting on the two giant canvases.

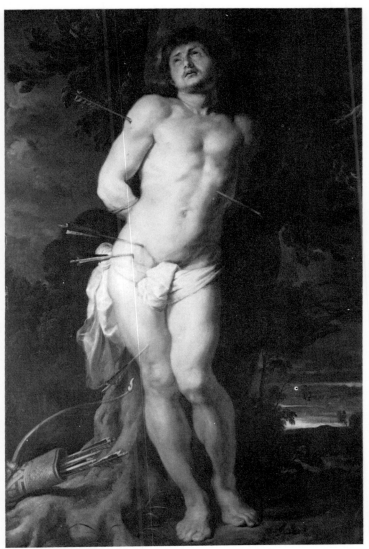

43 *St. Sebastian*. Ca. 1617.

44 *Abraham Sacrificing Isaac.* Ca. 1620.

The sketch for the Francis Xavier painting (fig. 45) already presents the entire situation of the final composition. It shows the India missionary on a high platform in front of a heathen temple. At his feet are witnesses to his miraculous deeds — the blind, the insane, the lame, and those raised from the dead. Above his head in the clouds is the *Fides Catholica*, the Catholic faith, from which also flashes the lightning that shatters the graven images. While working toward the final composition, Rubens altered so many details that, when seen all together, they produced a new draft. In the sketch Francis still appeared as a boorish daredevil who, like a Roman commander before his soldiers (cf. fig. 61), storms against the idols, gesticulating with both arms. In the final version (fig. 46) such militant traits have been removed. The pedestal on which the saint is standing is partially hidden by the outstretched arms of a blind man. The saint himself is rendered slimmer and more civilized. Now he points with his raised left hand to the source of heavenly might,

thanks to which the idols were destroyed. Francis is no longer understood as a redeeming, all-powerful, thaumaturgic court of justice, but rather as a court of mediation for a higher power. He loses the halo he bore in the sketch. For this relativization of Francis' personal power of persuasion, Rubens referred back to a pictorial idea that his teacher, Otto van Veen, had formulated in an emblem book in 1607 (fig. 47). There van Veen had illustrated how Herod Agrippa is struck by lightning the moment his flatterers hail him as a god. As van Veen explains in the pertaining text, this is supposed to mean that every power is subservient to a still higher power: *Potestas Potestati Subjecta*. Rubens also brings this reference into the pictorial event concerning Francis Xavier through a slight displacement of compositional elements. He draws the heavenly beams of light and the rows of supplicants into a diagonal, parallel relationship, which is guided by the gesture of the saint. The main idol is now falling backward into the center of the picture and can be compared to Decius Mus' fall (fig. 48). The manner in which the tombs of the risen dead in the lower left-hand corner of the final version and the blind and the lame in its lower right-hand corner are shifted further toward the center of the painting also corresponds to this cumulative orientation. The motion of the blind man's arms, together with the staircase seen from the side, creates an optical orientation which not only primarily includes the male figure with his back turned in the foreground, but also the companion behind Francis, who is now turned in profile. Extrapictorial sources of light touch only the group to the right in the foreground; otherwise, the heavenly apparition transmits so much light of its own to the picture that the painted world is able to elucidate itself.

Once the viewer finds guidance in the Francis Xavier painting, he will soon be able to see himself represented in other paintings. A comparison of the group crucifixion from 1620 at the Antwerp Museum (color plate 9) with the *Elevation of the Cross* in the cathedral (fig. 26) will show that the former almost formulates a counterproposal to the early altarpiece. The three crosses are staggered behind one another, and the thrust of Longius' lance, to which the picture's other name, *Le coup de lance*, is attributed, emphasizes this depth of motion. The event recedes from the viewer, from the robber closest to the front, through the ladder, which actually obstructs the view of Mary Magdelene. Beneath the cross, behind a slope, a group

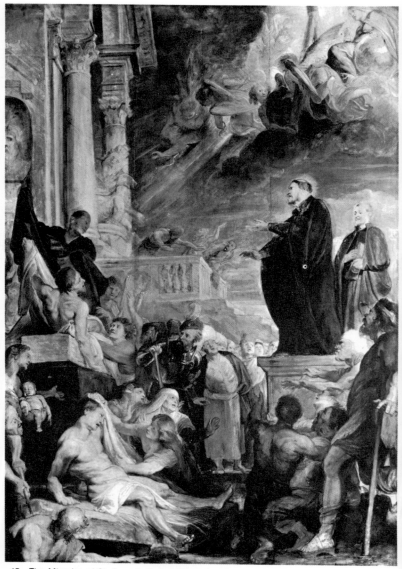

45 *The Miracles of St. Francis Xavier.* Oil sketch. Ca. 1617–1618.

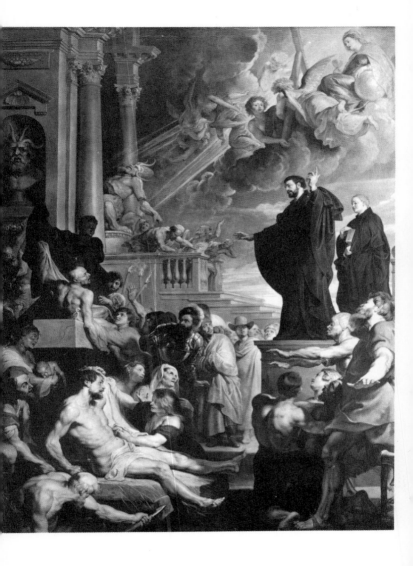

46 *The Miracles of St. Francis Xavier.* Ca. 1617–1618.

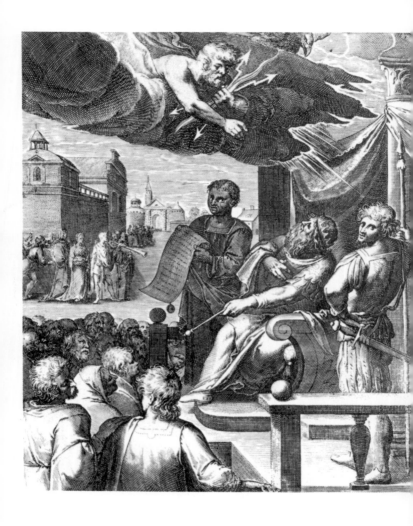

47 Otto van Veen: *Quinti Horati Flacci Emblemata*. 1607.

of onlookers gazes up at the crucified; thus the viewer sees himself placed into the interior of the picture.

This relocation of attention and the viewer's perspective inside the painting is employed to enable the actual viewing public to see represented in the painting itself its possible modes of relationship to the subject. The most eloquent example of this is offered by the *Adoration of the Kings* from 1624 (fig. 49, color plate 10), which was conceived for the high altar of the important church of the Abbey of St. Michael. The king prominent in the left foreground and the head of a cow which is turned toward the viewer in the right foreground form a kind of proscenium from which the eye is directed toward the center of activity. On the right-hand side the Holy Family is displayed, beset by curious gazes. The Christ child turns unabashedly toward the two diagonal throngs piled up both inside and outside the stall in an escalating scale of curiosity. With a penetrating focus, the Moorish King planted in the center of the picture gathers together the intensity of the gazes shooting forward from various directions — those of the shepherds, of two Spanish soldiers, and of the Four Corners of the Earth, who atop their camels urgently want to take part.

During the 1620s Rubens also succeeded in utilizing colors for this sort of internal orientation. Whereas the separation of the pictorial world from the viewer's world had been accomplished up until then fundamentally through the compositional and figurative layout and color, which persisted in playing an almost supporting role, now this separation was freed from its limited, separate existence and incorporated into the narrative context. The deep red of the royal cloak in the left foreground of the *Adoration of the Kings* (fig. 49, color plate 10) indeed excites the eye and causes all the colors in the main scene to recede; however, even there the red tone again emerges and unites with green, yellow, and brown tones against the bright blue sky into a mixed community of color, in which each member receives its portion from the palette as a whole.

When seen shining forth from its position among the multicolored early works (cf. fig. 26, color plate 2), the *Assumption of the Virgin* from 1625 (fig. 50), above the high altar of the Antwerp Cathedral, reveals most beautifully this elucidation and the new claim to participation that color was now developing in Rubens' work. He no longer used opaque, compressed, and dense charges of

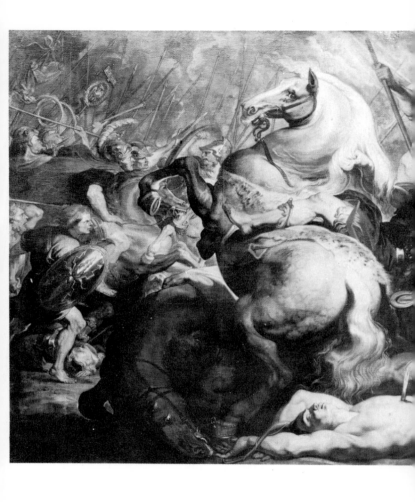

48 *The Death of Decius Mus (The Battle of Veseris)*. 1617.

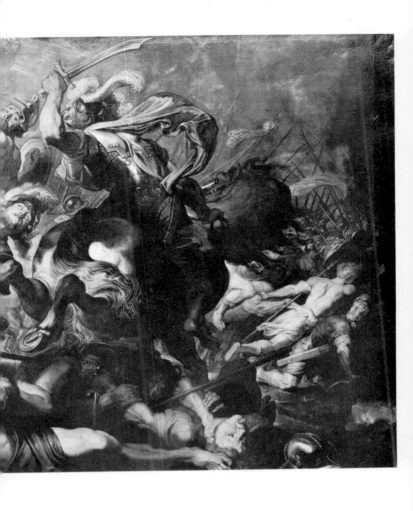

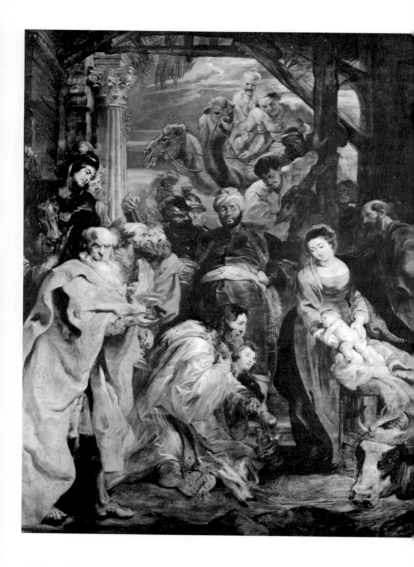

49 *The Adoration of the Kings* (cf. color plate 10). 1624.

color that have more or less no relationship in the painting, but easy, blended, irridescent colors, which are thickly applied and which reach out into all the corners of the picture, so that gloomy, shaded areas are increasingly crowded out. For the painting for the high altar of the Church of Augustines dating from 1628, Rubens prepared a large series of studies with uncommon thoroughness (fig. 51). The object of devotion, the Madonna's throne, is transposed to a high landing in the painting's upper half. The viewer is obliged to follow the direction of the indications, movements, and gazes in the chain of holy figures if he wishes to meet the gaze incidentally granted him by the parental couple while the Christ child exchanges rings with St. Catherine. Like a transcendent St. Francis (fig. 46), John the Baptist, in the upper right, assumes in a noble solo performance the role of pointing beyond the scene of betrothal. Nor do the colors in the painting indicate a static dominance. The brush sets the colors apart in numerous isolated facets. The red of St. George's standard flashes without acquiring undue weight, however. The various colors become a medium to unite, to dissolve solidifications, to further encourage the flow of things, and to elevate the removed atmosphere of the picture into a celebratory mood.

The 1620s are often described as the high baroque phase in Rubens' development, since his trend toward moving celebration can at the same time also be discerned in other artistic landscapes. But these tendencies remain among those indicative of his pictures since 1615. From an art historical point of view, they amount more to a contemporary revivial of the old Dutch masters' pictorial conception. Characteristically for Rubens in this phase, he gave an autonomy to his painting such that the energies previously directed outward now turned inward. Thus, Rubens sets the death of the Roman consul Decius Mus, whose deeds he painted for transposition into a series of tapestries, in a scenario, barricaded by corpses and horses, that sucks up all the power of motion (fig. 48). In the following years the lively contrasts are toned down primarily by means of colors which effect transitions, mediating steps which elucidate the picture and harmonize its structure. In the narrative paintings, those in which Rubens lays out histories and analyzes them in their individual phases, even naked putti can take over the task of establishing correlations and connections. The paintings from this period established Rubens' European success. In the second half

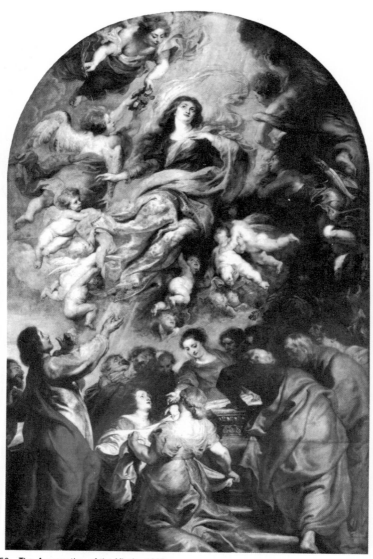

50 *The Assumption of the Virgin.* 1625.

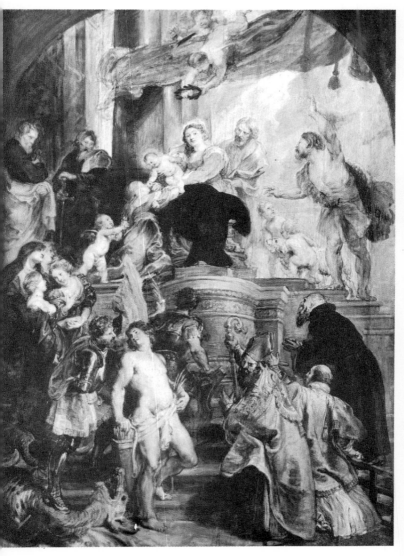

51 *The Madonna Enthroned with St. Catherine and Other Saints.* Oil sketch. Ca. 1627.

of the century his sovereign use of color would, after vigorous debate, enter successfully into battle against a shocked official academy of classical painting. And Winkelmann, followed later by others, would compare Rubens' narrative art to Homer's, since these paintings safely preserved realms of thought and feeling which had first to rediscover their relationship to reality.

A look at the portraits can corroborate the historical significance of this view of the formal development in Rubens' work. Around 1616 Rubens places the licentiate Hendrik van Thulden (fig. 52) in a seat set diagonally into the picture. One hand is lying on the arm of the chair, the other holds the book which van Thulden would apparently like to continue reading, since he leaves his finger in place. He looks at the viewer from an elevated distance. The light collected on his brow acquires a reflexive relationship to a patch of light on the wall. The robe's lengths of material, which angle up from the right, are picked up and pitched upright by the vertical elements of the wall. The area on the right-hand side and the window opening with its detail of the sky produce a meager, inaccessible background made up of blocklike elements. More than it would appear at first glance, the man's sure presence depends on the supporting framework, which secures his pictorial form from the background.

In the portrait of his friend, the Humanist and historian Gaspar Gevartius, painted about ten years later, the importance of the background is even more carefully specified (fig. 53). Gevartius was working at the time on an edition of the writings of Marcus Aurelius, and Rubens had hired him researchers in the subject at the libraries in Madrid. In the portrait, Gevartius has the bust of Marcus Aurelius directly before his eyes. This is indicative of his endeavor to conjure up, to engage in actualizing dialogue with the antiquarian material in the same manner in which Rubens also pursued his trade. Whereas this actualization in the philosophers' painting at the Pitti Palace (fig. 21) had been constituted so that the movement led away from the learned environment, now the Humanist is shown cloistered in an intimate, circumspect, and enclosed sphere. In the middle of his writing Gevartius is just granting the portraitist a fleeting, friendly glance. His seat functions as a base to the pilaster in the background, which optically keeps the scholar to the point, as it were. In letters from this period Rubens incidentally declares his respect for, but also his alienation from, the self-contented existence of the scholar, since

52 *Portraits of the Licentiate Hendrik van Thulden*. Ca. 1616.

he himself was becoming more and more involved in political activities. As a painter, though, he seems to have perceived and also participated in safeguarding retreat zones for the middle-class intelligentsia in an environment which increasingly reduced their power over their own affairs. His contoured world of images as a whole secures, unfolds, and stores those energies which then pressed outward for the first time in the eighteenth century with the Enlightenment, since which time they have continued unabated until the present day.

It is important to recognize that Rubens rendered pictorial reality independent from the reality of the viewer as a hermetic, independent sphere, but further that he shielded pictorial reality from the outside world at the same time as he pursued ever more purposeful and comprehensive practical politics in his actual life. As soon as it became obvious that the armistice with Holland, which would expire in 1621, could not be automatically extended, he entered actively into very extensive negotiations for the protection and restoration of peace: "Now is the time," he wrote in the year 1625, "for all loyal patriots to set into action all their efforts to the common good. Since we have already worked so hard toward that end, I pray that, with God's help, we will not have done so in vain."

52 *Portraits of the Licentiate Hendrik van Thulden.* Ca. 1616.

he himself was becoming more and more involved in political activities. As a painter, though, he seems to have perceived and also participated in safeguarding retreat zones for the middle-class intelligentsia in an environment which increasingly reduced their power over their own affairs. His contoured world of images as a whole secures, unfolds, and stores those energies which then pressed outward for the first time in the eighteenth century with the Enlightenment, since which time they have continued unabated until the present day.

It is important to recognize that Rubens rendered pictorial reality independent from the reality of the viewer as a hermetic, independent sphere, but further that he shielded pictorial reality from the outside world at the same time as he pursued ever more purposeful and comprehensive practical politics in his actual life. As soon as it became obvious that the armistice with Holland, which would expire in 1621, could not be automatically extended, he entered actively into very extensive negotiations for the protection and restoration of peace: "Now is the time," he wrote in the year 1625, "for all loyal patriots to set into action all their efforts to the common good. Since we have already worked so hard toward that end, I pray that, with God's help, we will not have done so in vain."

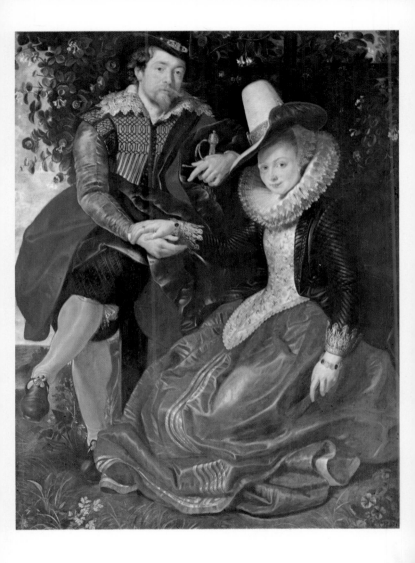

1 *Rubens and Isabella Brant under the Honeysuckle Bower*. 1609–1610.

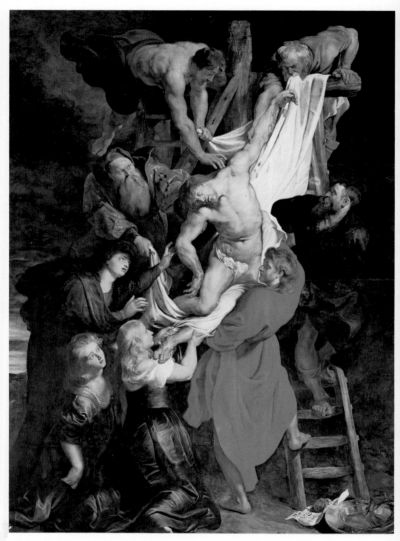

2 *The Descent from the Cross* (middle panel of the triptych in Antwerp). 1611–1614.

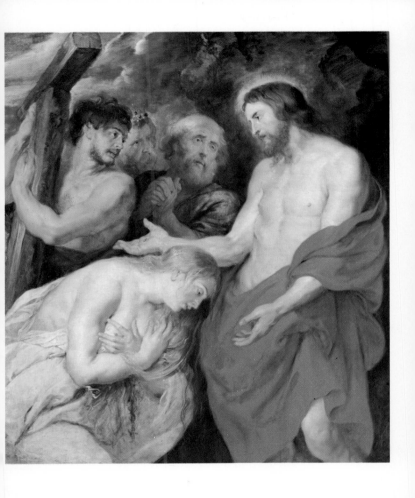

3 *Christ and the Repentant Sinners*. Ca. 1618.

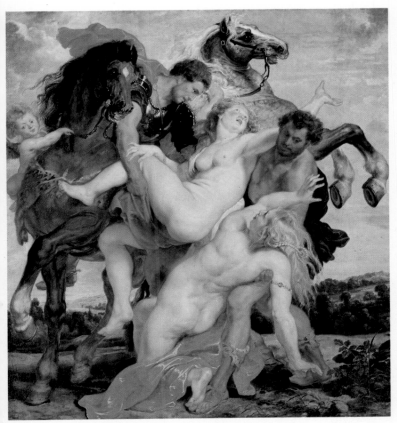

5 *Castor and Pollux Seizing the Daughters of Leucippus*. Ca. 1618.

◄─ 4 The Small *Last Judgment* (detail; cf. fig. 39). Ca. 1620.

6 *The Battle of the Amazons*. Ca. 1616–1618.

7 *The Battle of the Amazons* (detail; cf. color plate 6). Ca. 1616–1618.

8 *The Prodigal Son* (detail; cf. fig. 41). Ca. 1617–1618.

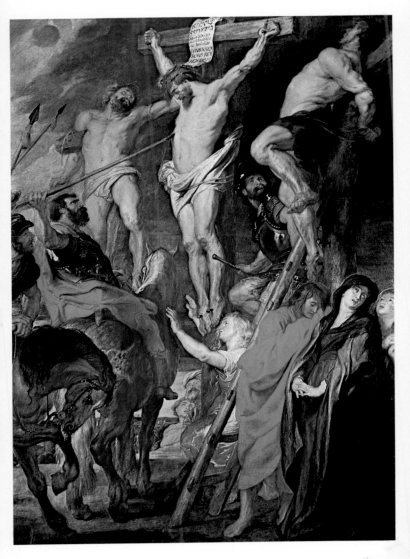

9 *The Crucifixion ("Le Coup de Lance")*. 1620.

10　*The Adoration of the Kings* (detail; cf. fig. 49). 1624.

11 *Henri IV Receiving the Portrait of Maria Medici.* Ca. 1622–1625.

12 *The Horrors of War* (detail; cf. fig. 68). 1637–1638.

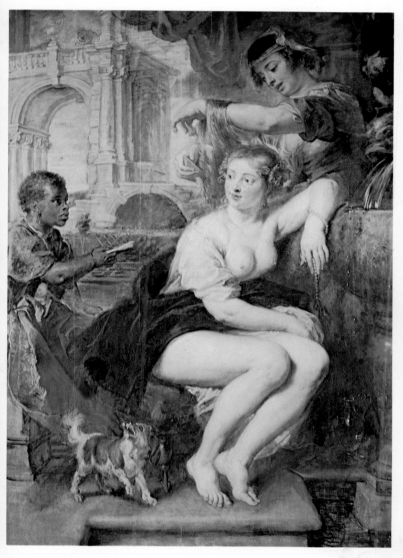

13 *Bathsheba*. Ca. 1635.

14 *Conversation à la Mode*. Ca. 1633.

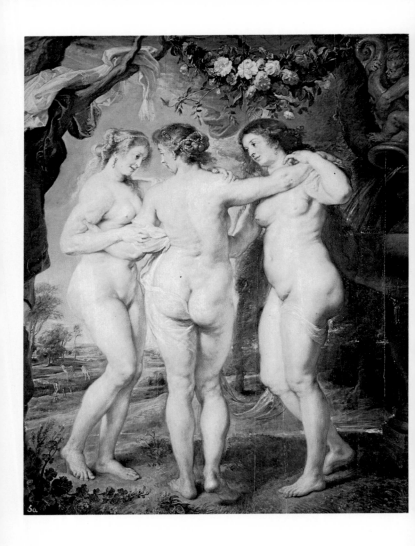

15 *The Three Graces.* Ca. 1639.

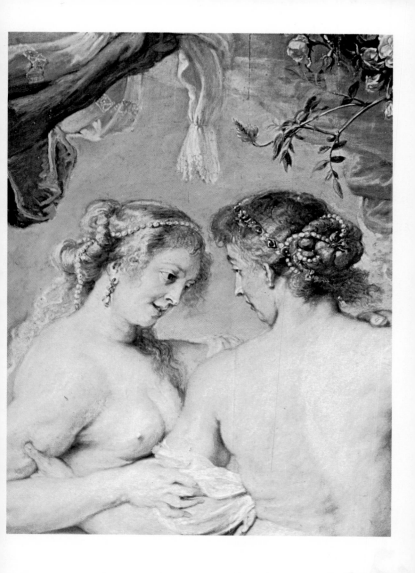

16 *The Three Graces* (detail; cf. color plate 15). Ca. 1639.

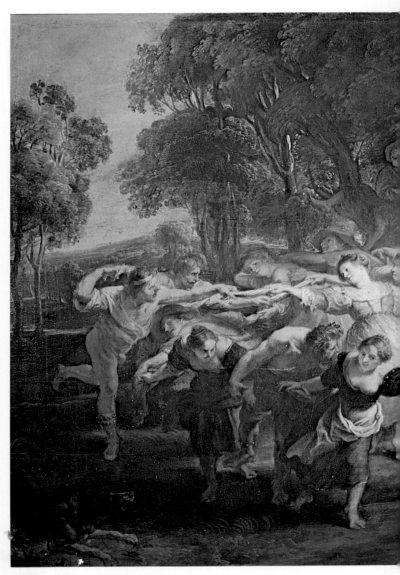

17 *The Rondo*. (Dance of Italian Peasants). Ca. 1633.

18 *Harvest Landscape with Rainbow.* Ca. 1635.

19 *Harvest Landscape with Rainbow* (detail; cf. color plate 18). Ca. 1635.

20 *The Castle at Steen, Autumn*. 1636.

21 *The Judgment of Paris* (detail; cf. fig. 82). 1639.

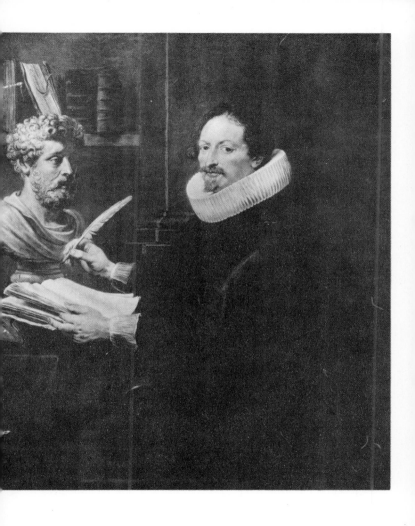

53 *Portrait of Gaspar Gevartius*. Ca. 1628.

54 *The Duke of Lerma on Horseback.* 1603.

III. The Political Sphere

The portrait of the duke of Lerma on horseback (fig. 54) is the first picture of profane content that Rubens painted for a political court. The duke had been the omnipotent favorite of the Spanish king when, in 1603, Rubens accompanied a dispatchment of gifts to Valladolid from the duke of Mantua. The favorite's wish that the young artist portray him as a horseman brought Rubens face to face for the first time with a phenomenon which would strongly influence the political scenario of the seventeenth century: namely, that kings often had to place their real power into the hands of favorites. Rubens would have dealings with the most important of them during his artistic and political career, such as Olivarez, Richelieu, and Buckhingham. Rubens himself repeatedly voiced the opinion on this phenomenon that he did not consider it desirable for kings to function as stewards to their favorites. On this point he was in agreement with many critics who also found fault with just this duke of Lerma.

When the duke of Lerma had Rubens portray him on horseback, he placed himself in a stance competitive with the equestrian portraits of kings, the most famous of which (the one Titian had painted for Charles V) Rubens had certainly already seen in the royal castles. To show a ruler riding was regarded as a statement on his power to reign the state: one governs a horse the way one governs nations and subjects. Rubens' decision to portray the duke riding out of the picture directly toward the viewer signified a Caesar-like pose, since this manner of representing Caesar had become common; the frontispiece of a book comparing Henri IV of France with Caesar (fig. 55), for example, illustrates this genre of equestrian portrait. Thus

Rubens directed all his efforts toward satisfying the amibition and hunger for power of this favorite of the king. The frontal equestrian image Rubens introduced to painting would grow in popularity during the course of the seventeenth century as a form of baroque royal portraiture.

From its unsettled, excited repertoire of forms, this early work of Rubens, however, develops qualities which rescue it from a simple panegyric reception. The kind of contact established between the duke on his horse and the viewer cannot be simply described as the demeanor of a lord with respect to his subjects. Away from the tumult of battle, beneath a shady tree, the bareheaded rider equipped with a staff of command has a rather quiet relationship to the viewer. The horse faithfully reinforces his rider's outwardly directed gaze. In the duke's expression is a note of depression, of "melancholia," into which those who knew him often saw him sinking. It is an ancient observation on the psychology of power that power can be as emotionally damaging to its possessors as to its victim. Thus, the themes of princely glory are modified in Rubens' picture by a simple gesture, through which the omnipotent but isolated minister seeks human sympathy.

It would be nearly twenty years before Rubens again had the opportunity to paint at this political level. Neither the duke of Mantua nor the rulers of Spanish Netherlands called on Rubens for their more expensive political platforms. In Italy he had provided the Genoese nobility with stately portraits. In Antwerp he only functioned as a court painter when he was commissioned for a portrait of the archduke and his wife, or when, working from old prototypes, he mustered in dynastic succession the ancestors of the ruling house of Burgundy. Before Rubens furnished the great courts of Europe with his representative, imperial cycles in the 1620s, he became familiar with the domestic, urban middle-class sphere in Antwerp. After his return from Italy his first commission was for an *Adoration of the Kings* (fig. 56) as part of the decorations for the Antwerp town hall, in which the ten-year armistice between the southern and northern Netherlands would be signed.

Abraham Janssens painted an allegory about the relationship between the city of Antwerp and the Schelde for the same hall. The Dutch had used their strength at sea to blockade the river and thus the port of Antwerp as well. Rubens gave the following outline of the

Hercule. Thesee. Achile. Alexandre.

VRTVS DOMAT VIRTVS. IN FEROCES FEROX. VINCERE AVT MORI. SOL SOLVS IN ORBE.

AVT CÆSAR AVT NIHIL. CEDIT VICTO-RIA FORTI.

LES
PARALLELES
DE CESAR, ET
DE HENRY IIII.
PAR ANTHOINE DE
BANDOLE,
Avec
Les Commentaires
de CESAR, & les An-
notations de BLAISE
DE VIGINERE,
De nouueau Illustrez
de Maximes Politiques
par ledit DE BANDOLE
DEDIE
A Monseigneur
le DAVLPHIN

A PARIS,
Chez IEAN RICHER rüe St Iean
de latran a l'arbre verdoyant
et en sa boutique au Palais sur le
perron Royal

Cesar. Henry IIII.

SIC VIRESCIT IVSTVS. HONOS DVCIBVS VBI LABOR. AGITATA VIRESCO.

Auec priuilege du Roy. L. Gaultier sculp. 1609

55 L. Gaultier: Frontispiece for Anthoine de Bandole, *Les vies parallèles de César et de Henry IV*. Paris, 1609.

56 *The Adoration of the Kings.* 1609 (retouched 1628).

city's predicament: "Our city is prostrated like a body taken ill with consumption which, little by little, is wasting away. Every day the number of inhabitants decreases, and our unhappy city has no means, through industry or through trade, to hold itself up." According to Rubens, as long as the Spanish acted in conformity with the "maxim of tyranny," whereby "friends can go to ruin if enemies [the Dutch] are thus harmed," there was no future for Antwerp. It was only to the city's advantage that a concerned provincial government under Albert and Isabella, often operating against Spanish principles, sought to restore it as a new cultural center. New models for the broken municipal organs grew out of this, which Rubens helped to formulate. The *Descent from the Cross* for the Old Guild of the Bow offered that group a deeper concept of community (color plate 2). For the large hall of the Shooting Club of St. George in Antwerp, around 1613 Rubens painted the *Hero Crowned by Victory* (fig. 57), now in Cassel, in which a draft for political conduct was formulated. The champion of virtue reveals himself to the viewer unsparingly. He sits

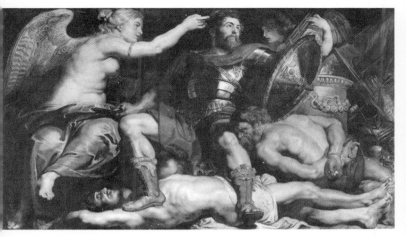

57 *Hero Crowned by Victory (The Victor's Triumph).* Ca. 1613.

erect on top of several allegorical figures: on "Discordia," who is made
recognizable by the snake's head; on top of a deathly pale outstretched
corpse from whose hands slips a torch and who perhaps signifies
"Pallor" — fear and trembling; finally, on top of a bound figure who,
whimpering, rubs his cheek against the hero's thigh and who most
probably represents "Ferocitas" — savagery tamed. The hero uses him
as a stand for his round shield. This he has turned in the direction from
which his watchful eye suspects yet another danger, against which he
thought it necessary to aim himself with the quivering dagger in his
right hand. The picture's most common title, *The Victor's Triumph*
(fig. 57), might stem from newer conceptions of a victor's demeanor,
but more probably from the fact that Napoleon I took the painting
with him to Fontainebleau, where he was supposed to have hung it
over his desk. In reality, however, the hero was not victorious over po-
litical enemies, but rather over psychic characteristics which,
according to interpretations of the time, were primarily caused by
wars. The painting is also based on a notion, supported by Lipsius,
among others, that the first task of a strong state must be to repress
the passions of men and classes so that, after the chaos of religious
and civil wars, civilian life can flourish again. That the hero is not
alone in the picture indicates that his rigorous victory will probably

not be long-lived. From a certain distance, necessitated in the first place by the drawn dagger, Victoria tries to slide a laurel wreath onto the hero's head. A guardian angel approaches from the background, where weapons and standards are piled up around a sacrificial altar, and offers the hero a fasces, the symbol of harmony. Obviously they are trying to coax the hero from an inflexible to a more relaxed comportment. While the Dutch shooting clubs were becoming celebrated as drinking and carousing societies, Rubens delivered a political treatise to the now functionless shooting clubs of Antwerp: the passions deemed negative by contemporary theories on emotions — combativeness, envy, and savagery — should be held down by a show of strength in order that the positive emotions — harmony, kindness, and sociability — might again evolve.

Even a harmless nature study illustrating a tree knocked down in a storm (fig. 58) can be drawn into such realms of thought. The image of the broken tree first surfaced in emblems. It is contrasted with the solidly rooted tree, which represents unshakeable virtue. The proudest tree is uprooted by a violent storm, whereas a reed survives unharmed to mock it: "Thus a patient mind is victorious when it avoids rage" (H. Junius, 1565; see also in fig. 55 the picture of the storm on the lower right).

Rubens used this study of a tree for a landscape painting illustrating a wild boar (Dresden). The erring boar runs into the fallen tree's broken branches and thus falls prey to dogs and hunters. Two victims of passion encounter each other in this example: the tree which extends its grandiose gesture into the depth of the picture and the game which is baited by the instruments of the hunter's passion.

The paintings of the hunt which appeared in Rubens' repertoire around 1615 drew their reality from the lively debates held at the time about the significance of the emotions. Rubens once wrote that he wished the nobleman's bellicosity, as it was exhibited in his love for dueling, would be put to better purposes. Yet it was precisely in the aristocratic circles of the court that Rubens' hunting pieces enjoyed a particular popularity.

Around 1615 Rubens painted a series of four hunting scenes for Maximilian, the duke of Bavaria, which included "a ruthless hunt of monstrous crocodiles," as Sandrart reported in 1675; it is still located in Munich. Rubens painted the *Lion Hunt* (fig. 59) around 1621, probably for the palace of an English nobleman. The subject matter

58 *Tree Felled by a Storm*. Ca. 1617–1618.

59 *The Lion Hunt.* Ca. 1621.

of these hunting scenes, which were completed in rapid succession
through the active participation of Rubens' studio, is many-leveled
in terms of the history of culture and politics.

Since Xenophon, hunting was considered the "training ground for
military service." Countless ancient reliefs of the hunt handed down
the fitness exercises to which rulers in particular like to submit.
From the sixteenth century on, however, hunting was no longer
permitted to just anyone, since the princes had also monopolized for
themselves the right to hunt and only granted it to those belonging
to the highest ranks. Gevartius (fig. 53), in a commentary on a later
Rubens painting, recalled the general right to hunt when he quoted
the "law" from Plato's *Republic*: "Let no one hinder these hunters who
truly please the gods from hunting wherever and however they
wish." Yet there were also always voices which spoke out against
hunting, on principle. Seneca had already felt that the danger which
accompanied hunting was the penalty for the "lack of moderation
and predilection for something so vain." Sancho Panza also criticized
Don Quixote's desire to hunt when he claimed that these animals had
certainly done nothing wrong and that it was unnecessary for "kings
and princes to place themselves in such danger." According to

60 Follower of Jan Scorel: *Lion Hunt* (detail).

Francis Bacon, whom Rubens read, poets and historians are the best witnesses to how "one emotion can be used to subjugate or restrict another, as hunters utilize one animal in order to hunt another." Rubens showed himself to be familiar with such thoughts when he wrote in 1627 that the government of France cultivated "the use of others' passions to reach their own goals."

Rubens' paintings of the hunt illustrate high points of emotional states, and they all illustrate moments of extreme danger. It is always the assistants — Turks, Arabs, or farmers — who are in danger of their lives or already dead (cf. fig. 59). The participating knight, however, like St. George, gallops forward to deliver the decisive blow, since the coup de grâce was the privilege of the lord of the hunt, and his assitants were only allowed, as in a ceremony, to help out. Despite these predetermined societal limitations, the events in Rubens' hunting pieces are more than ritual acts. In the first place, man and animal are shown to be on an equal footing. Whereas in the numerous woodcuts and engravings which portrayed such hunting events, and from which Rubens received much stimulus (fig. 60),

the lord of the hunt need only follow through with his lance thrust to the lion from a position of safety atop his horse, in Rubens' work the battle as a whole remains undecided. Only because Rubens captures the moment of greatest danger does something like solidarity between lion and lioness, as well as lord and servant, enter into the picture. In this situation, not only the knight is a savior. Indeed, Roger de Piles mentioned in his description of the *Lion Hunt* that the final hour has come for the man on the left trying to ward off the lioness if his comrade, who is about to attack, is not successful in rendering her harmless in time. The artistically staged, sporting social game instantly turns into the emergency of an event in nature in which all preestablished regulations are suspended.

Rubens' hunting pieces bring a maximum of elementary movement and heightened immediacy into the picture. Yet Jackob Burckhardt described a principle of form specifically in the Munich *Lion Hunt* which he also understood in a moralistic sense as a basic category of Rubensian pictorial thought, and which he, not incidentally, had first observed in a master of the High Renaissance, in Corregio — namely, the principle of "equivalences." By this he meant a "veiled symmetry" which achieved a repose and balance in the most kinetic of Rubens' compositions. Through this principle every weight has a counterweight, every position a counterposition. In the *Lion Hunt* a reclining S subliminally coordinates the violent activity and fleeing motions of the figures. Energies shoot together with enormous force around the lions in the center of the picture and instantly ricochet back. Yet explosivity of this kind shoots nothing out of the pictorial context and into the viewer's space. Everything that is to be done is accomplished in the picture itself. Whereas the champion of virtue in *Hero Crowned by Victory* (fig. 57) still refers to a fictitious danger exterior to the picture, the look of deathly fear on the Arab in *Lion Hunt* who has been torn from his horse meets the viewer like the look of one of Rubens' damned who is being cast into hell; his destiny is fulfilled within the context of the picture. The moment that links and binds all the figures together is made permanent by a clear artistic economy.

Rubens' hunting pieces were not the least important works to establish his name in the great courts of Europe. Princes visited his studio in Antwerp, and a companion to one of them, incidentally, marveled at the high prices the painter was able to demand.

From the beginning of the twenties, nevertheless, Rubens systematically expanded his radius of activity to include the great courts of Europe and thus also the decisive centers of political power. During the decade between 1620 and 1630 he was constantly traveling. From the outset, artistic, diplomatic, and political goals were intermingled. Rubens produced for the palaces of the powerful his great cyclic paintings, portraits, and tapestry designs; at the same time, however, he searched out, negotiated, and actuated the possibilities for political treaty relations which could bring peace to his homeland. There, in 1621, after the armistice treaty had expired, war activities, for which the radical groups in Spain and Holland had long since been prepared, had immediately flared up again. Rubens negotiated on instruction from and in agreement with Isabella, the regent queen, who appointed him secretary of her secret council in 1629. This won official status as a negotiator for Rubens, and diplomacy temporarily became his principal occupation.

The most important recognition underlying Rubens' interregional involvement was the insight into the link between local circumstances and the development of relations on an international level. Just as Flanders was with Spain, Holland was politically tied with England, whereas France was interested in seeing to it that both blocs kept each other occupied so that it could have a free hand elsewhere. Rubens once spoke about the "entanglement" of all relationships among the European powers. Progress on one front required support all-around. If it was possible to negotiate a peace treaty between London and Madrid, then it would also be possible to effect one between the two Netherlands. Thus, it was not enough to find peace-keeping individuals here and there; Rubens cultivated a lively contact with such individuals in Holland. Peace depended much more on the development of relations between the international powers. Rubens knew, too, that the peace treaty he strove for between London and Madrid could not be a moral arrangement, but rather that it could only be effected if it were based on the real interests of both powers. The peace treaty had to be the result of the statecraft of both parties. Rubens was well acquainted with this central concept of political theory and practice of the time, and he knew always to take it into account.

His entry into such a context of thought and action also shifted the intention and effect of the art brought into this context. His lan-

guage of forms is immediately clear, appellative, and transparent, when he intends to cater to a local, familiar, urban audience. In the realm of the courts though, new, many-leveled, precarious involvements among party interests were continually forming in the national and international, personal and social spheres, involvements which could never be unequivocally stabilized. Another pictorial language was necessary for these courts. If it were directly and relevantly expressive, as in everyday life, then at court it would serve as a diversion and amusement. If it was supposed to participate in the political education of the mind, however, then it had to be capable of complex and differentiated interpretations to avoid the danger of being forgotten with the next shift in political parties. Rubens was able to say about one of his paintings which belonged to a thoroughly political cycle that it "does not allude to the statecraft of a present-day government nor to any individual." Thus he granted his work a status founded somewhere beyond actual concerns and conflicts. This picture was one from the Medici cycle.

The French queen Maria Medici was driven out of Paris by her son in 1617 when he came of age. In 1620 they entered into an expedient agreement which made it possible for her to return to Paris. To demonstrate immediately that she was also still politically present, she ordered a cycle of paintings in two parts from Rubens for the galleries of her newly completed official palace, the Palais de Luxembourg. One of these cycles was to glorify her own life, the other, that of her husband, King Henri IV. Thus, Rubens had to function within an extremely tense political atmosphere. The careful contrivance of the themes. the rejection of some of his suggestions, the long deliberations on details such as armor and costumes indicate that he had to reckon with a close evaluation and examination by his court public. When Rubens appeared in Paris in 1622 to discuss the terms on the spot, he first had to furnish the opposition party, Louis XIII, with sketches for a series of tapestries on the life of Emperor Constantine (fig. 61). He completed this task with his left hand so that at the same time his would be free for the Queen Mother, whose friendly attitude toward the Hapsburgs allowed him to hope that it might work to the advantage of the Netherlands.

A commission of this kind, prejudiced by complicated entanglements of power and political climates, could no longer be carried out artistically in terms of certain claims to truth or reality. No one

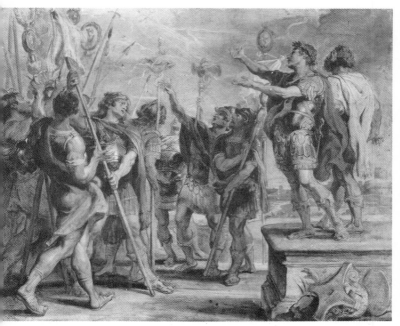

61 *The Vision of the Monogram of Christ.* Ca. 1622–1623.

expected to learn the historical truth about the life of the queen from
the painting cycle. Much more important were the evaluations and
criteria according to which this life would be brought into the
current political game. Neither everyday nor descriptive narrative
prose were adequate for such criteria and such lofty evaluations of
political life. Therefore the courts had long since established the use
of an artificial language. Ancient deities, guardian angels, al-
legories, and symbols had to take over when direct discourse might
have been an affront or when it was a question of interpreting real
circumstances and subjugating them to one's own goals.

This illusory world of mythological loftiness superimposed over
reality has made it difficult to approach even the Medici cycles since
the nineteenth century. It was not understood that painting's capac-
ity, cultivated since the fifteenth century, to bring reality discrimi-

nately and deceptively into a picture could overlay this reality with fictive characters and concepts. It is probably easier to comprehend today — now that our relationship to reality is everywhere determined by abstract signs and symbols — why Rubens made this particular language his own. Yet his letters verify that he knew very well how to distinguish between reality and appearance, or, as he put it, *sostanza* and *apparenza*.

In the historical paintings in the Medici cycle, those fictive characters embroiled in every aspect of the events take on a very peculiar role. It can be observed that the mythological figures used to fill the paintings manifest a more "real" and more "natural" attitude than do the historic individuals themselves. Whereas their movements correspond to their rank and the dictates of etiquette, those of the putti, gods, and goddesses are often quite uninhibited; they grasp onto, incite, and enjoy to the fullest what is constrained and confined in the historical framework by manifold considerations.

Using scenes from Maria Medici's childhood, Rubens planned a painting which portrayed her first appearance on the stage of world politics (color plate 11): King Henri IV is presented with Maria Medici's portrait during the Savoy war. The presentation of a portrait before a marriage conformed to a tradition of the court which can be documented from the late Middle Ages. In reality as well, Henri IV had been presented with such a portrait of Maria Medici, although the money of the Florentine archduke's daughter interested him far more. Everyone knew this, and everyone knew to value the marriageability of this genial and well-like king, who was, above all, popular with women. A written draft for the cycle worked out at the court with Rubens specified the following for the picture: "Jupiter and Juno decide, on Francia's request, to provide King Henri the Great with a wife. They dispatch Hymen and Cupid to show the queen's portrait to the king, who considers it with loving attention. He confers with Cupid, who displays her beautiful image before his eyes. Below, two amoretti, one of whom carries off the king's helmet, the other his shield as an indication that the king of France's marriage will bring the gift of long-lasting peace." Rubens held to this plan, although Francia intervenes directly, instead of through the two deities, to convince Henri to marry.

Rubens portrays the king as a chivalrous and gallant bon vivant and connoisseur. Captivated, Henri removes his left hand from the

62 *The Madonna Adored by St. Gregory and Other Saints.* 1607.

63 *The Capture of Paris by Henri IV.* 1627–1631.

hilt of the sword and with his right plants the staff into the ground in
astonishment. In an oil sketch preserved with many others in the
Alte Pinakothek in Munich, the bride in the black-framed picture
looks down at Henri. Now, in the final version, she is looking at the
viewer and accordingly overhears the compliments paid to her. In
other particulars Rubens also has the historical figures in this picture
adhering to the game rules set by courtly novels, in which the loving
presentation of a portrait continued to play a role up through the
Magic Flute. Rubens emphasizes this trait to the point of coquetry
when he lends the portrait a Mariological flavor: Henri worships
Maria's portrait in the same manner that St. Gregory worships the
image of the Madonna of Vallicella (fig. 62) in a painting Rubens had
executed in his youth and placed above his mother's tomb.

The chronological elements of the picture — Henri IV, the
portrait of Maria Medici, the landscape — form one level of lan-
guage, which Rubens delivers in a gallant tone. The other, the
fictive level of language, is differentiated from the first. Some of the

128

64 Rubens' Atelier: *The Victor Seizing the Opportunity for Peace*. Ca. 1630.

allegorical figures are portrayed naked and can correspondingly move and express themselves more freely. As was long since the common practice at court wedding festivals, the actual event is also acted out by the mythological figures in the picture. Rubens took advantage of this opportunity to give his own interpretation to the event. Jupiter and Juno, the *Dii conjugales*, are set apart through color from the historical scene. Juno's outspread golden cloak, along with Jupiter's deep red cloak, extends so far across the field of vision that it contrasts sharply with the surroundings, which on the whole consist of subdued, gray-brown and green harmonious colors. Yet even with their affected mannerisms, Jupiter and Juno offer the example of an intimate relationship, which recollects and intensifies that of the *Honeysuckle Bower* (color plate 1). The more intimate notion of marriage is brought into play in this picture as a contrast to a marriage arranged for diplomatic reasons. The abstinence from

weapons is characterized as a precondition to and consequence of marital bliss. While Henri's right hand releases the hilt of the sword, the two putti drag off the movable parts of his armor into the landscape, where in the background a city is still in flames. Even Minérva, whom Rubens usually portrays banishing Mars (cf. fig. 65), is able to confidently approach the virtuous hero, who has given in to positive emotions. In light of all the rumors and tales concerning the love lives of Henri IV and Maria Medici, Rubens could not seriously have expected his portrayal of them as an ideal couple to be credible. He was, however, probably trying to get across the idea that public and private relationships are interconnected. This he accomplishes with the help of an abstracted, fictitious world of characters, which is blended into the historical account in order to elaborate that which the actual story left open.

The cycle on the life of Henri IV never materialized, although Rubens did not appear to be any less fascinated by him than were others later on, from Voltaire to Thomas Mann. Numerous intrigues and then the exile of Maria Medici, who fled to Antwerp and Holland and finally to Cologne, thwarted the project, so that only fragments of it are preserved today (fig. 63).

Around 1630 Rubens followed up on an idea which he had first sketched out in connection with the Henri cycle. This painting, *The Victor Seizing the Opportunity for Peace* (fig. 64), enjoyed a high appraisal in the seventeenth century but is only handed down to us today in a drawing from his studio. The victor, in full armor, is drawn forward from the right by Minerva and led before the naked "Opportunity," who, staring bashfully straight ahead, is nevertheless encouraged by the "good government"—a cupid—and Chronos. Minerva takes up her locks and offers them to the victor, who is thus supposed to seize by the hair the opportunity for peace. Pictorial images of this kind might well appear misplaced in the middle of the Thirty Years' War. Nevertheless, Rubens used every opportunity to declaim them in ever new variations.

During his stay in London, where, from 1629–1630, he successfully negotiated a peace treaty between the English government and Spain, Rubens began discussions with the king on the decoration for the ceiling in the newly appointed Banqueting House in London. Rubens was able to draw on his experience with the ceiling paintings in the Jesuit church of Antwerp (fig. 44). The whole design was to

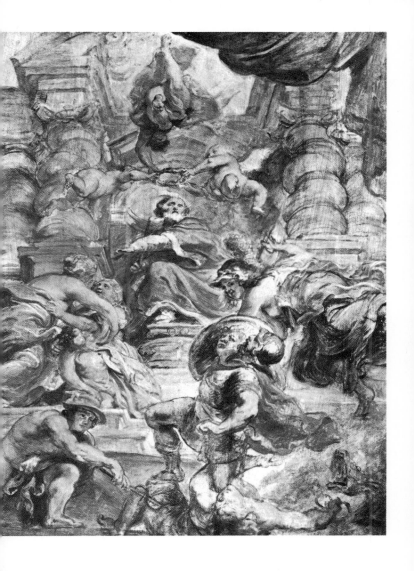

65 *The Wise Government of King James I.* Oil sketch. Ca. 1631.

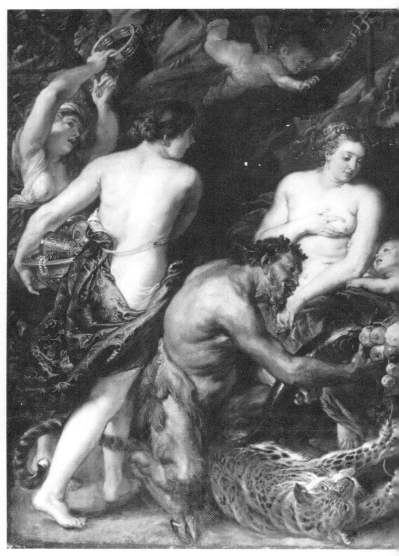

66 *War and Peace*. 1629.

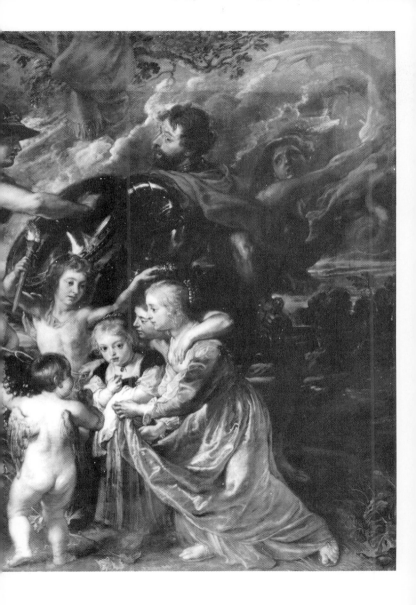

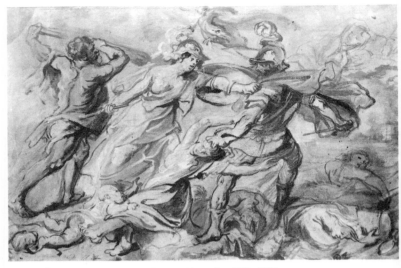

67 *Minerva and Hercules Battling Mars.* Ca. 1635–1637.

serve as a glorification of the reigning king's father. In one of these ceiling panels Rubens portrays King James I before a huge throne balachin as the master of war and peace. On the left at the foot of the throne, Pax and Abundantia embrace each other and point to the fact that prosperity is only possible through peace. On the right Minerva shoves Mars, the god of war, into the abyss occupied by the Furies, and Mercury, the god of diplomacy, rushes to her aid. Guardian angels flutter into the scene to crown the king for his unequivocal decision in favor of the proponents of peace (cf. the oil sketch, fig. 65). Rubens completed the painting in Antwerp but did not himself bring it to London, "since courts are an abomination to me" (cf. p. 183).

In the meantime his peace negotiations had again become shaky; peace for the Netherlands was out of the question. As a result, the major political piece that Rubens had given the English king as a farewell present to seal the treaty was now invalid (fig. 66). This allegory of peace activated a long literary and artistic tradition of judgments on war and peace. In the foreground Peace displays her blessings; in the background Minerva drives out the god of war and

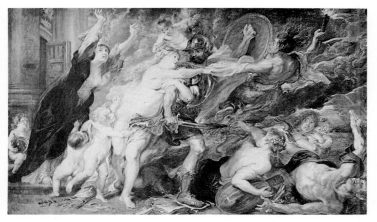

68 *The Horrors of War* (cf. color plate 12). 1637–1638.

the Fury Alecto. Mars looks back anxiously, since behind him rises the world of peace. As the goddess of peace, Venus sits above and nurtures a little boy with streams of milk from her breast. Around her the consequences of peace luxuriate in life: a satyr empties the fruit out of a cornucopia; a panther, tame and harmless as in the golden age, snatches at the grapes; on the left a woman enters bearing goblets of gold; behind her another woman celebrates Mars' expulsion with a tambourine dance. The victory of diplomacy, the "tools" of which a triumphant putto flies forward with above, reawakens the joy of living. Rubens adds a realistic note to the allegorical celebration by having two children on the right enter the world of peace dressed in contemporary costume. These are the children of his painter colleague Gerbier, who had been his partner in negotiation on the English side for a time and with whom Rubens lived in London. As if they had yet to be taught the way of life in peace, the two girls are guided and accompanied by Cupid, by a woman, and by Hymen, the god of marriage. For artistic clarity, Rubens made use of a compositional mode reminiscent of a classical era in painting, the High Renaissance. Broadly arranged in an open, turbulent pyramid, those wishing to partake in Peace's blessing gather around a Venus enthroned like a Madonna. This is the pattern of arrangment in which Leonardo's or Raphael's Holy Families fall into formation (cf.

135

fig. 9). Rubens endows Gerbier's children with a shy restraint, a characteristic practice in older altarpieces portraying the children of benefactors. While this organization in the picture's foreground restores a lost order, in the background, Mars and the Fury are driven out of the picture in diagonal flight. Rules of form combining both classical balance and high baroque movement here appear linked to the political circumstances. In his treatise on imitation in the plastic arts (cf. p. 175 ff.), Rubens also draws a connection between the capacity for artistic sensitivity and the political and moral condition of the world. The painting, which is now in London, not only illustrates, but concretizes artistically, the simple desire Rubens had expressed in a letter: "As for me, I wish we lived in a golden age rather than an age of iron."

Just a few years later Rubens evidently no longer saw reason to assign utopian elements to a political painting. In the color sketch at the Louvre (fig. 67) executed around 1635, the driving force with which Hercules and Minerva pursue the god of war sweeps away all vestiges of human civilization. Rubens' last word on this topic, the allegory of war painted in 1637 for the grand duke of Tuscany (fig. 68, color plate 12), Burkhardt described as the "eternal and unforgettabl frontispiece to the Thirty Years' War." In a letter to Justus Sustermans, who was court painter in Florence, Rubens explicated in detail the content of this painting (cf. p. 184): how the arts and sciences, family life and fertility are trampled underfoot, how Europe is forced to lament because the temple of Janus has been opened and Venus does not seem able to keep Mars captive. He does not mention that the Three Graces, here drawn on the trampled page, was one of his favorite subjects at the time (color plates 15 and 16); or that he had developed the figure of Pathos, Europe lamenting, from a figure which illustrates most expressively a mother's agony in his painting of the *Massacre of the Innocents* (fig. 71); or that he took the Venus from the *Offering to Venus* (fig. 77), where she holds up the mirror to the purified statue of herself. The employment of such tried and true expressive figures makes a knowledge of handbooks on iconography and ancient themes unnecessary; the essence speaks for itself. The figure symbolizing order, still found in the London allegory ten years earlier (fig. 66), has now been banished. Now the vehement diagonal thrust out of the picture, which in the former piece had been relegated to the background, rules the field of vision. The pair of

columns rising straight up on the left edge of the picture serves only as a point of optical reference from which to observe the events of the rout: Europe lamenting and falling forward, Venus being dragged away, the futile clutching of the putti, and the successful attack of the Furies. With the point of his sword, Mars, pressing forward, threatens the harried victims of the Iron Age, who are all that remain of the Golden Age. In the allegory in London, they had still taken part in a harmonious pictorial order. A few years later Rubens could apparently no longer justify this within the framework of this theme.

IV. THE ARTISTIC SPHERE

"For three years now," Rubens wrote in 1634, "I have, with the grace of God, again found peace of mind, since I have given up all activity outside of my very pleasant vocation [dolcissima professione]. Destiny and I have become acquainted. . . . I have hewn through ambition's golden knots in order to reclaim my freedom."

The later work of Rubens, who had withdrawn from the political stage in order to devote himself solely to his artistic career, is in some respects puzzling and difficult to understand. Often, the pictures contain an esoteric content, a quite personal and particular significance. Artistically, Rubens recapitulates the experiences from all the phases of his development; he pushes them to extremes in one direction or another and juxtaposes them. Since his house and studio were well ordered, and he himself was exceedingly well off, Rubens was evidently in a position to produce a pure, artistic excess which situated many later works beyond an audience in a very peculiar world of forms. They might be seen as testimony to an individual history which is trying to extract itself from the web of circumstances of history in general.

When Rubens again saw one of his earliest Antwerp pieces, *The Adoration of the Kings* from 1609 (fig. 56), in 1628 in Madrid, he added a strip of canvas to it on the right-hand side. On this he painted himself mounted on a horse looking back benevolently on the scene of the royal donation. This remarkable comment on an early work opens a dialogue with the past history of his own forms which persists through the entire last decade.

The fact that as late as 1638 Rubens ordered a large copper engraving after the Antwerp triptych, *The Elevation of the Cross* (fig.

69 *Christ Bearing the Cross*. Ca. 1636–1637.

26), supports the observation that some of his early formal principles regained their significance for him during the last decade. In *Christ Bearing the Cross* (fig. 69), which Rubens painted for the high altar in the church of the Abbey of Afflighem around 1636 or 1637, the Herculean figures, the centurion on horseback, the lamenters grouped atop one another — all of whom appeared in the *Elevation of the Cross* — appear once again. Though the idea of triumph is stressed in the earlier painting, here it is brought to the fore only to be cut short suddenly. With all pomp the procession moves along the picture's diagonal up toward Golgotha. It comes suddenly to a halt when Christ collapses and Veronica kneels down to wipe the sweat from his brow. According to legend, she only held out the cloth to Christ, who returned it to her with the imprint of his true face. In contradiction to this tradition — and Rembrandt would attentively register this new feature — Veronica becomes a benefactress. Thus the entire triumphal procession falters on this moment of human solicitude. In the midst of tearful activity, a moment of breathless quiet ensues in which Christ casts a last look at the viewer from his bleeding eyes. The appellative formal repertoire of the early years is, in this work of a later period, led back to an emotive center.

Among Rubens' later works there are examples of gruesome directness which have since then hardly been surpassed. In 1637 when, at the instigation of the later finance magnate to Louis XIV and enthusiastic collector Eberhard Jabach, Rubens was given the commission for an altarpiece to St. Peter, he was allowed to paint the scene of his choice from that saint's life. Rubens chose the crucifixion of St. Peter (fig. 70) and added to it the decisive lessons in form he had acquired in his early years in Italy. In his version of the crucifixion, he borrowed from corresponding portrayals by Caravaggio and Guido Reni, which he had seen in Rome. Both, however, had Peter facing into the picture. Rubens, on the other hand, has Peter toppling forward directly out of the picture in a reversed frontality. If we turn the picture upside down, we can recognize the image of Seneca with his hands bound, from the Pinakothek in Munich (fig. 23). With an almost sarcastic irony Rubens allows a childlike angel swooping down from heaven to complete the picture by placing a laurel wreath on Peter's head and by pressing the martyr's palm branch into his hand. The logic of continuous narrative, which Rubens had himself developed in the 1620s, falls apart here.

70 *Crucifixion of St. Peter*. Ca. 1638.

Just as a putto, against all reason and factuality, tries to present St. Peter with the signs of blessedness, in the *Massacre of the Innocents* (fig. 71) an angelic host strews thornless roses as a symbol of the promise of paradise in the midst of a merciless, earthy bloodbath. An unmoved King Herod remains sheltered behind a classical architecture with columns defended by a dense wall of soldiers, who ward off a phalanx assault of grieving mothers, while hired guards murder the defenseless children on all sides. Here a brutal form of statecraft and the mother's natural right to her child collide. "Political reason has precedence over civil reason [*raggion di stato, che precede alla civile*], as Rubens had already recognized in 1627.

We might regard the portrayal of the rape of the Sabines as a profane counterpart to the *Massacre of the Innocents* (fig. 72). Many of the attacking Roman men can also be found in the *Massacre*. Further, the diagonal format of the composition as a whole bears similarities in the positioning of the embodied power of command, in this case Romulus, and the direction of this power against its victims. The abduction scene from horseback in the right foreground might be seen as a late, ironically treated paraphrase of the *Daughters of Leucippus* (color plate 5). Here, the raison d'état sovereignly turns men's passions toward its own ends. The reaction of feminine nature — similar to that of the *Massacre* — varies according to rank and station.

One of the most extensive projects that Rubens had to execute in conjunction with his studio during his last decade was a comprehensive cycle of paintings for a hunting lodge, the "Torre de la Parada," for which Velázquez had made the arrangements. The Spanish king, Philip IV, wanted it decorated with paintings after Ovid's *Metamorphoses*. Rubens selected the most sensitive and lyrically successful, as well as the most brutal and bloody, incidents from this literary model. Ovid's version of the story of Tereus and Procne in his *Metamorphoses* (VI) had always seemed so unbearable that artists would only illustrate it timorously, but no one had ever painted it before. King Tereus had betrayed his wife Procne with her sister Philomela. He had raped her, ripped out her tongue, and set her out in the forest. When his wife found out, she rescued her sister from the forest, with her help killed her own son Itys, served his cooked flesh to Tereus, and then showed him his son's head. Rubens illustrated this scene (fig. 73). With wild determination the sisters

extend the boy's head toward the king. In the background the servant disappears through the door. The king's fatherly feelings are wounded in the most gruesome manner; in horror he knocks over the well-laid table with his foot, since "that was the beginning of mankind's contamination at the table," (Pausanias X. 4. 8). Rubens was able to push the expression and treatment of emotions to extremes in his later works. Like Shakespeare, Rubens lays them bare, declares and determines them so conclusively that all that remains for the following century is to model and to rationalize them.

In releasing such emotions, Rubens often made use of formal principles he had already perfected for his paintings before 1615. The great historical paintings of the later period again abandon a development of spatial depth or perspective in landscape. The figures again perform on the picture's most superficial plane, and the compositions again open up toward the viewer; this is clearly identifiable in the allegory of war in Florence (fig. 68, color plate 12), in the *Crucifixion of St. Peter* (fig. 70), as well as in the *Banquet of Tereus* (fig. 73). Despite this foreshortening of distances, the viewer is still not directly addressed or drawn into the pictorial context. The energies pressing outward in the later paintings no longer actually reckon with an active reaction, and yet neither is such a reaction fixed by the counterenergies within the image.

These unrestrained pictorial relationships, which are no longer harmonized either inwardly or outwardly, can be observed in a specific, delimited series of later works. In these paintings, all of which share a vertical format, Rubens has extracted single details from thematic contexts which in the twenties he had still narrated epically with an even modulation; this he does in order to fix each detail in an unresolved dramatic moment. The *Andromeda* in Berlin (fig. 74) is no longer the object of a minutely rendered rescue attempt (cf. fig. 40); rather she is unprotected and open, displayed to the viewer in chains, the embodiment of a demand for release. Lipsius included Andromeda among those who had suffered a kind of crucifixion even before Christ. This comment probably led Rubens to develop the clear reminiscence of a female Christian's martyrdom.

Just as Perseus in this Andromeda, King David in *Bathsheba* is also relegated to the background (color plate 13). We can perhaps infer from the fearful look with which the Negro youth hands her David's

71 *The Massacre of the Innocents.* Ca. 1636.

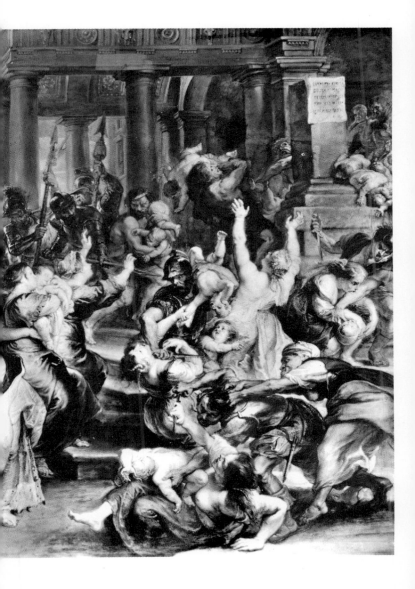

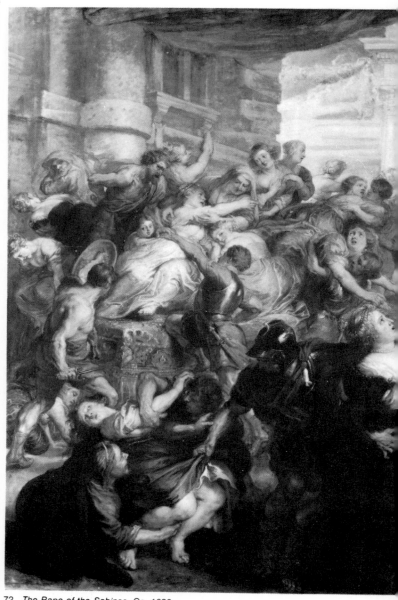

72 *The Rape of the Sabines.* Ca. 1636.

73 *The Banquet of Tereus*. Ca. 1636–1637.

letter that the king covets Bathsheba now that he has seen her bathing. That the king is about to send her husband to the front in order to acquire her, however, fades out of the picture. Released from past and future history (2 Sam.: 11, 12), she is set free as a feminine object of desire.

Another work in this series, the well-known *Pelisse* in Vienna (fig. 75) also exhibits an isolated figure. Since a fountain is still visible in front of the character in the background and the woman is situated on a terrace, she might almost be a Bathsheba. In any case, a look at the figure "Occasio" from around 1630 (cf. fig. 64) supports the contention that she is detached from a narrative context. The pose and the gesture of the figure are based on an ancient statue of Venus. Probably, in accordance with a widespread humanistic tradition, Rubens wanted to assign Helena Fourment the epithet of a beautiful Aphrodite. While rendering the ancient statue, Rubens certainly had in mind his demand for pictorial vivification as formulated in his treatise on the imitation of ancient sculpture. But if this is a statue

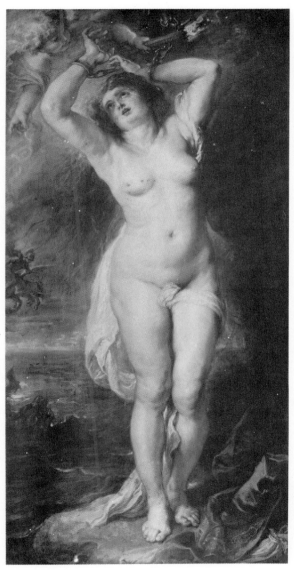

74 *Andromeda*. Ca. 1635.

75 *The Woman in the Pelisse* (Portrait of Helena Fourment). Ca. 1638.

come alive, then we could also regard the artist as a Pygmalion whose wish for a living statue of his own production has been granted by Aphrodite. Despite the riddles posed by interpretation, riddles further complicated by the fact that we recognize a close relationship to a Titian portrait, the painting remains evident, the epitome of sensuous consciousness, and approachable without the aid of literary props.

The painting of *St. Cecilia* (fig. 76) provides another example for this monologue of pathos. Rubens began by filling a small wood panel with her figure alone; then he extended the panel and allotted the putti, the landscape, the columns, and the dog to this goddess of music. Despite these new surroundings, she actually has no audience. She removes her hands from the keys in order to listen to that other music inspired in her by heaven.

The extraction of a single figure from a narrative context is a countermove to the hermetic, internal harmony, the balanced multiplicity of relationships, in his paintings from the twenties. We could characterize the process as a protest by the early single figures — Seneca, for example (fig. 23) — against the indifferent enclosure of the picture during the middle period, if the later work as a whole did not teach us that Rubens would certainly take up this direction again but not, however, its significance. If we want to speak of the detached late single figures as an "escape" motif, then we can find just as many examples in the later works which we would have to characterize as a "break-in" motif. While this close-up procedure excludes any context within the picture, other later works place particular emphasis on establishing such contexts just so that they may be shown opening up and unlocking. This form of interpenetration and juxtaposition of two pictorial positions appears clearly in a series of procedures in Rubens' later works.

Again and again we encounter in Rubens' later works protected, often idyllic interior domains into which strangers, outsiders, are being led or from which they are being banished. In the *War and Peace* painting in London (fig. 66), contemporary girls are being led into a circle of allegorical and mythological figures, who are delighting in Peace's blessings. The fictive beings no longer become involved in real or historical proceedings but admit and receive whoever seeks them out.

For the *Offering to Venus* (fig. 77) Rubens took his inspiration from

76 *St. Cecilia*. Ca. 1639–1640.

Titian's pictorialization of Philostratus' literary description of a painting (I. 6). Yet Rubens expanded the festival to include the washing of the statue of Venus, in reference to Ovid (Fasti IV. 133 ff.). A matron in contemporary costume attends to the washing, while in front of her a companion tends the burning tripodal urn. The putti, who in Titian's painting formed a confused mass, here dance a roundelay around her (cf. fig. 84 with Rubens' interpretation, p. 181 ff.). As a gesture of invitation, the dancers keep a place in their circle open at the right edge of the picture, where two kneeling women, also dressed in contemporary costume, are shyly trying to offer their devotion.

In *Conversations à la Mode* (color plate 14) in Madrid, a gallant company sitting in the middle ground listens to a lute player who has joined them. The three merry women try to draw a standing woman into their circle, who should then be followed by the couple on the right. Like the Roman abducting his Sabine (fig. 72), a cavalier escorts in a rather proper woman, who is dressed more for the salon. She evidently hesitates, since a putti has to push her from behind. In the background a loggia architecture is sketched once again, under which several couples have just been surprised by an artificial rainstorm from the vault. A group sculpture of the Three Graces stands above the fountain in the grotto; we have here, then, a sanctuary of these goddesses, who at the time symbolized genuine friendship.

Rubens portrayed the graces again in a large painting (color plates 15 and 16). Turned completely away from the viewer, they form their own circle, in which two of them try to pull the third still closer. "There are three graces because in friendship one has to be able to give on one occasion, on another to take, and on a third to do both at the same time. That is why they are painted giving their hands to one another. . . . They are naked because nothing should remain hidden among friends. . . . They are smiling because those who give to one another should do so cheerfully. . . . They accompany Venus because Venus loves friendship and peace. From the graces mankind receives abundance, wealth, tranquility, and peace of mind, for the fertility of the fields depends on peace more than anything else, since in war there can be neither tranquility nor abundance" (Perez de Moya, 1585). We have to take into consideration such contemporarily familiar suggestions for interpretation if

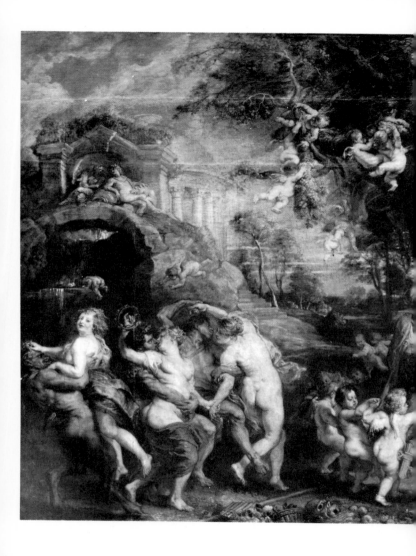

77　*The Offering to Venus.* Ca. 1632.

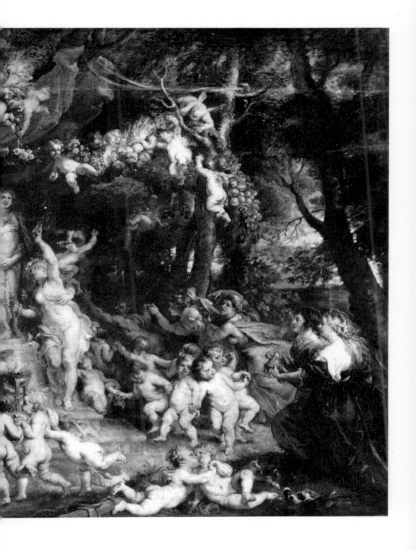

we want to reconstruct the quiet spiritual drama which Rubens imparted to those pictures, in which fleshliness does not mean carnality but rather a claim to reality. Only by way of such a train of thought does it become clear why Rubens concurrently has Mars treading on a drawing of the Three Graces in his allegory of war (fig. 68, color plate 12).

In Rubens' paintings where contemporaries appear in mythical circles, contemporary experiences and hopes also pass into the sphere of imagined happiness. There are only a few examples in which Rubens left such a realm of harmony intact.

In the middle panel of the St. Ildefonso Altar (fig. 78), which Rubens produced in 1632 on the order of the infanta Isabella, the scene of the miracle is set quite in relief and turned toward the interior. A group of saints is situated in front of the choir pews, which, arching back toward a niche, are those in which Maria appeared to St. Ildefonso. Beneath the scent of roses, spread by the angels hovering above, reigns an almost classical precision and an almost sentimental peacefulness. Surprisingly, however, as in earlier times, Rubens chose the triptych form for the altar, a form which had all but vanished, not least of all because of his influence. As a consequence of the Tridentine prescriptions for painting, the appearance of benefactors in an altarpiece had already become uncommon and was now very rare. Rubens allows the church architecture of the middle panel to overflow onto the side wings, from which angle the benefactress and her husband, who are situated beneath a glowing red curtain and in front of a lectern covered with a fiery red cloth, look into the closed sphere of the central panel. Their patron saints, Elizabeth and Albert, assume the role of guiding their wards into the central panel. This relationship can be observed in other contexts in the mythological and allegorical pieces.

The altarpiece Rubens intended for his burial chapel in Saint James Church in Antwerp was one of his last (fig. 79). An unidentifiable saint approaches the Madonna, who is turned sideways in profile, and he is greeted happily by the baby Jesus. They form a tightly knit, intimate core. They are closely surrounded by three female saints. In a second circle, two male saints demonstratively assume their guardian roles. On the left St. George energetically holds his banner aloft; in the foreground, his back turned toward the viewer, St. Jerome indicates with his solemn gesture and severe

78 *The Miracle of St. Ildefonso* (middle panel of the triptych). Ca. 1630–1632.

expression that he, like a gatekeeper, protectively controls entry to that central domain.

This sort of solution and dissolution, congestion and expulsion often arises in the later works as the result of a direct dialogue with formal accomplishments of years past. Insofar as those achievements concurrently reflected and forged the European art scene as a whole, this is a dialogue with the entire development of baroque painting. Rubens also received a particularly strong impulse from Titian, after reviewing and copying this master's chief works in Madrid in 1628. But also in other circles, Titian, and along with him Veronese, gained a new pertinence in the thirties, since he could give substance to the court's developing taste for brightness and festivity. Rubens, however, only availed himself of Titian for the formal development of his own artistic intentions, which contradict Titian's general stylistic preference for the grand, celebratory, and splendid, even in those cases where he defers to it. Among his circle of clients, who had spoiled him for decades, opposition was becoming noticeable. In Spain a few people at the court wanted to have Rubens' paintings removed; in Afflighen the high altar (fig. 69) was taken down a few weeks after Rubens' death. In 1691 even the Jesuits of Neueburg finally dissociated themselves from the large *Last Judgment* (fig. 38) "due to its offensive nudes," which had long since given offense.

Nevertheless, it is not fair to apply to the old Rubens, who was plagued by the infirmities of gout, the same well-loved, tired cliché that is so eagerly applied, for example, to the aging Rembrandt: that his style in old age reflects the mode of expression of a lonely man who, seeing death and the final judgment before his eyes, relativizes all earthly affairs. From the beginning Rubens was too open to death and, right up to the end, too concerned with the world to allow for such an evaluation, if such an evaluation is at all appropriate to the seventeenth century. Not only the allegory of war in Florence (fig. 68, color plate 12) shows that Rubens was completely incapable of leaving the course of external affairs alone, but also the enormous undertaking in 1634 of providing the pictorial decorations for the cardinal-infante Ferdinand's entrance (cf. fig. 4), by means of which the city of his birth wished to express its hopes and desires to the new regent. Even his forms and, most of all, his later colors reveal a world-embracing, aesthetically effective radiance which has nothing recognizably remorseful about it. The structures

79 *Madonna with Saints*. Ca. 1639.

of Rubens' later paintings do no spring from a spiritual attitude, but from a state of consciousness. They are not unfathomable compulsions for expression, but rather reproducible, pictorial arguments which also keep the joyous, Arcadian world of magic alive. The *Dance of Italian Peasants* in Madrid (color plate 17) illustrates positively vital children of nature, who lightheartedly swing their plump maidens under the "bridge" two couples build for them with

the help of two scarves. At first glance we observe only the elementary movement, and perhaps that in the foreground an impetuous youth twists around to kiss his partner. This breach of rules, however, has its consequences. The chain stops and strains so that it breaks right behind the couple. It breaks at the most delicate spot, where the only sensitive girl with a fair complexion and delicate feet is dressed in violet. She is torn further away, while her right arm reaches backward, seeking out the hand of the youth whose attempt to steal a kiss meets only air. Thus a break, a doleful interruption, enters into this prancing round.

Rubens' late landscapes were not made to order, but were, rather, the voluntary products of his seclusion at the Castle of Steen. They are often deemed his most personal and happiest achievements. He had always painted landscapes, scenes of the country and of labor, and, in the twenties, expressive scenes of inclement weather. In comparison to these, his later landscapes are more expansive and panoramically open. Whereas the *Landscape with Cows and Milkmaid* (fig. 42) illustrated an internal, enclosed unraveling of events, a continuous geographic formation with an inner repose, the *Harvest Landscape with Rainbow* (color plates 18 and 19) is organized along entirely different lines. In the boundless landscape which opens up to all sides, groups of trees are arranged in the left and right foreground like gateposts, over which the spectrum throws its arc. Just as the groups of figures in the thickly peopled pictures of Rubens' later period can be distributed loosely and unconnectedly in the space (cf. fig. 77, color plate 14), we encounter regions in his later landscapes which are always differentiated and shoved against one another; and as in the altar-pieces and mythological pictures where the unfolding of the pictorial realm, the correlation of internal and external elements, becomes thematically significant, the later landscapes also nearly always provide a regulated means of access from the outside. In the *Harvest Landscape with Rainbow* (color plate 18), the rainbow freely draws the eye over a broad, sunny countryside panorama in which nothing stirs or moves. In contrast, the areas in the foreground illustrate various farming activities. On the path leading diagonally out of the picture toward the left, a wagoner driving his haywagon into the picture to the stockpile beneath a group of trees encounters and greets a group of three farmers who, with their tools and jugs, are moving out of the picture. The herd of cows a farmer is driving out of the stream will follow them in that direction.

There are similar dual relationships in the landscape at the Pitti Palace entitled *The Return from the Fields* (fig. 80), made famous by Eckermann's description. On the great arc of a patch circumventing a horse pasture, a rack wagon follows a quickly moving flock of sheep into the depth of the picture. The lash of the wagoner's whip into the picture is answered on the right by a farmer who points the way out of the picture to a group of women, some of whom are carrying heavy charges. Also the work area in the foreground and middle ground of this landscape is contrasted to a broadly expansive, flat countryside in the background. Even the bands of clouds near the church towers in this background seem to be climbing upward.

The morning landscape *Castle at Steen, Autumn* (color plate 20) illustrates how a farmer with his goods sets out to market, as the lord of the manor makes his first rounds. As the path moves from the castle area surrounded by trees out of the picture, on the right a musketeer with his dog scares a flock of birds out of the woods so that the survivors will fly out over the broad plain flooded with sunlight, where other birds already hover. Lines of sight emanating from the stump and the undergrowth in the foreground fork out toward the castle area, across bridges, into the distance alongside trees lined up like an aqueduct.

Through such interrelationships between coming and going, near and far, a stability arises over and over again. These interrelationships contain something of the melancholy of an observation Rubens noted down on a landscape study with trees at the water's edge (fig. 81). An English collector thought this comment so remarkable that he inscribed his own translation beneath Rubens' words: "The shadow of a tree is greater in the water and more perfect than the trees themselves, and darker." Leonardo da Vinci had always made note of this kind of comparison between the actual and reflected realms of things. This observation was the outgrowth of Rubens' lively interest in all the contemporary advances in the natural sciences, philology, history, and literature; he himself was deeply involved with the production of a perpetual motion machine. Yet within its calculation of actual and reflected experience, of reality and appearance, this power of observation also contains practical political experience. In a letter, Rubens cites and quotes Machiavelli, who advised the princes to take into consideration that "in public opinion many things appear larger at a distance than they actually are at close quarters." These are the intricacies in the ostensibly naively established facts

80 *The Return from the Fields.* Ca. 1635.

which make Rubens' otherwise so open and transparent late pictorial
world enigmatic.

When Goethe presented Eckermann with an engraving after the
landscape at the Pitti Palace (fig. 80) and had him describe it,
Goethe pointed out to him an "error" which Eckermann had not
noticed: that the shadows in the landscape fall in different directions
and that they therefore contradict natural logic. Goethe saw in this a
mark of the artist's freedom from nature, and he drew on comparable
inconsistencies in Shakespeare to prove that the great artist need not
be subservient to any rules of constraint. Goethe could well have also
cited a letter of Rubens in which he enumerates the errors in an
ancient landscape painting which had come to his attention in an
engraving of the work: "I have viewed with great pleasure the
engraving of an ancient landscape which appears to me a true
example of artistic imagination and which depicts a locale found
nowhere in nature — since those arches, one of which curves over the
other, can be found neither in nature nor art and could assert
themselves in this manner only with great difficulty. And those little
temples scattered about on the top of the cliff have neither enough
room for this type oif building nor a path on which the priests and

sacrificers could climb or descend. Even that round water vessel is unusual, . . . because it sheds more water than it contains . . . Indeed, it seems as though the entire scene has been painted by a skilled hand, though the optical principles do not appear to have been carefully observed since the lines of the building do not intersect on the horizon at a point set at the same height. This leads me to the conclusion that, although Euclid and others have established quite outstanding optical principles, this science was not as widespread as it is today." Probably only because this science was well-known in Rubens' time did he allow himself in his later works to violate its rules. He scrupulously transposed the landscape in the upper left of the *Offering to Venus* (fig. 77), which he had described as incorrect and unbelievable.

The inconsistencies, breaches, or imaginative achievements which Goethe ascertained and Rubens himself described are decisive factors in his later works. In the state art academies which were springing up, where, in the name of discipline, pupils were made to rehearse faithfully the rules of proportion and perspective and where Rubens' faulty drawing was reproached, the pupil was referred to the helpless alignment of the balustrade in the portrait of Helena (fig. 12); or the

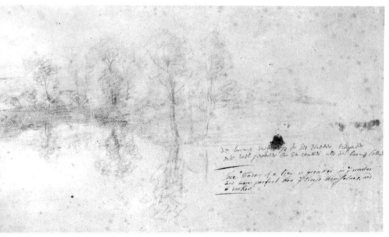

81 *Trees by the Water at Sunset*. Ca. 1635.

forgotten piece of balustrade to the left in *Conversation à la Mode* (color plate 14); or the discontinuity of the flight of stairs in front of Herod's palace in the *Massacre of the Innocents* (fig. 71); or the church columns before an open sky in the side wings of the Ildefonso altarpiece (cf. fig. 78); or the foreshortening of the cross with its peculiar crosspiece in *Christ Bearing the Cross* (fig. 69). In Rubens' figurative representations the student was referred, for example, to the inaccurately drawn hat brim in the *Self-Portrait* in chalk (fig. 18); or Europa's proportion in relation to the temple door in the allegory of war at the Pitti Palace (fig. 68, color plate 12); or Mercury's unattractively extended legs in the *Judgment of Paris* (fig. 82, color plate 21); or those of St. George in the painting above the artist's tomb (fig. 79); or, finally, the sense of beauty which the cartilaginous and flabby body parts simply overlooked in conformity to the dictates of fashion (fig. 75, color plates 15 and 16). These "errors" were the results of presumptions and jests which were becoming less and less tolerable in serious historical painting. In an early work, Rubens already had a putto reaching through the canvas of a Madonna painting (fig. 62). During the last decade, embellishments of this kind accumulated, for example, when the enraptured St. Cecilia draws her foot out of her slipper (fig. 76) and when in the same picture the putti point to the notes as pedantically as they try to place a wreath on St. Peter's head in the depiction of that saint's crucifixion (fig. 70); when a cupid urges his mistress on while stepping on her foot (fig. 82); or when the little dog at Bathsheba's feet (color plate 13) tries to imitate the pose of her body and legs, or runs between the legs of a serious gentleman on the far right in *Conversation à la Mode* (color plate 14).

Rubens' late pictorial thought no longer harmonizes nor unites nor develops in logical correlations, but puts harmonious, corresponding, and fortunate relationships into action in order to question them within the picture itself or to make them confront actual expectations. He no longer directly addresses nor summons the viewer, and he no longer presents him with exemplary, standardized models for interpretation and response; rather, he is able to reveal the thematic significance of the discrepancy or disparity between actual experience and imagined idealization in the image itself. What is no longer possible on the outside can no longer be free from contradiction in the images themselves.

The subtly yet clearly implemented dissociative themes of incursion and excursion, which disrupt all determinacy and finality, carry through even into the technical processes of Rubens' later works.

The compositions in Rubens' early works are constructed from their individual elements. The individual figures are initially planned in studies in chalk and then remain self-contained even in the painting. The procedure corresponds to a bright colorfulness, which is limited to a local descriptive intention. Rubens then developed with increasing virtuosity a technique which prefigured the composition on the basis of the total conception. Presketched individual figures became rarer, but, conversely, the number of surviving compositional sketches grew in which the details are only suggested.

Numerous oil sketches for the large projects of the twenties still survive (figs. 45 and 63). They were prized and collected from early on. They served either as *modelli* to be presented to the client per contract before the actual execution or as *bozetti*, which were useful for his own deliberation or as models for his studio assistants. Both possibilities were uninterruptedly cultivated from the earlier through the later periods of Rubens' work; yet they revealed their full significance for the operation of his studio only when his clientele grew to include all of Europe.

In 1621 a German visitor to Rubens' studio described his impressions: "Many young painters were sitting in the room all working on different pieces which Rubens had sketched out in chalk and on which he had here and there added a spot of color. The young artists had to completely finish the pictures in color, at which point master Rubens himself put on the final sketches and colors." The institution of oil sketches made it possible to promote further this division of labor. Working from rough guidelines in the sketch, the landscape, animal, or flower specialists employed by or independent from the studio could work on those sections of a painting calling for their particular talents. At the end Rubens retouched them even as the varnish dried, applying his own distinctive touches. For these studio productions Rubens charged his often quite sharp-eyed customers less than for those he executed himself, though he was reluctant to recognize the import of such distinctions (cf. p. 184 ff.). After all, his paintings contained his "invention," in any case, which outweighed the execution, according to art theory at the time.

This rationalized mode of manufacture, in which a design is realized by many different hands, was, significantly, discredited with the dawn of the age of high industry in the nineteenth century, because the artist was no longer allowed to explore contemporary productive potentialities, and his work was conventionalized as an expression of his spiritual constitution. Rubens' mode of production, which was not entirely new, formed the preconditions for the unimaginably widespread influence and expansion of his art and its contents. Correspondingly, this influence and expansion was generalized and became, when the opportunity arose, independent from specific circumstances. Because the pictures often had to be transported over great distances, preferably rolled up, most painting was done on canvas in the twenties. The large early altarpieces (fig. 26, color plate 2) for Antwerp were still painted on wood, a material Rubens otherwise preferred whenever possible.

The organization and productivity of Rubens' studio was independent from the narrow restrictions which the guilds placed on atelier production. Rubens was a member of the Antwerp painters' guild but surprisingly enough never its dean. Occasionally, he made donations, probably also to appease envy and ill will. Guild regulations limited the number of assistants a master could employ. As a court painter Rubens was not bound by these limitations. He could hire as many assistants as he wished. They did not even have to be members of the guild, which the guild regarded as "scabbing," since actually, according to their provisions and privileges, no one could be a practicing painter unless a guild member. Only very few of Rubens' atelier assistants were registered on the guild roster, on which they otherwise might never have been enrolled. The storm of young painters on Rubens' studio, which he reported can be explained by the fact that through court privileges his studio was open to any talent, regardless of the guild's petty admissions criteria. On the other hand, these unincorporated assistants were totally bound to Rubens' studio, since they were not permitted to work independently for clients.

This set of circumstances guaranteed on-the-job discipline. In fact, only one case of a conflict with an assistant is reported. This interesting model of production sociology appears to have functioned as teamwork in which such independent artistic natures as van Dyck, and for a time also Jordaens and Jan Brueghel, could participate. The

legal foundation of all this was the freedom granted by the court, although his studio was never a state operation. In contrast to the first state manufactories, Rubens' shop was independent. Rubens drew his yearly salary regularly from Brussels without thereby compromising his freedom of movement.

This advanced state of labor organization was so efficient that, even during Rubens' frequent and prolonged absences due to his diplomatic activities, production continued at full pace. The aging Rubens also made good use of this circumstance. At the beginning of the thirties he once again had to direct all his energies to enable his studio to take up his new artistic intentions. He met the deadline for both of the major projects of the last decade: the decoration for the cardinal-infante Ferdinand's entrance (cf. fig. 4) and for the "Torre della Parada," for which in March 1638 he dispatched no less than 112 paintings. This efficiency made it possible for Rubens to retreat to the Castle at Steen during the summer. In 1640, though, he had to smooth over one breakdown in the works. At the English court one painting was immediately recognized as an uninspected atelier product. Rubens felt obliged "to admit that the painting in question is not from may hand. It was painted entirely by a very mediocre artist of this city (by the name of Verhulst) and was even after a drawing of mine which I had produced on the spot. It is in no wise worthy to appear in His Majesty's collection." It appears that toward the end he did not hold a very tight rein on his studio and occasionally let the assistants supply things for him. In 1638 he ordered a canvas with three painted heads: "You would do well to cover it with one or two unfinished panels to keep it out of sight on the way. It seems odd to me that we hear nothing about the wine from Ay, since that which we brought with us recently has already been consumed." Because in his last years Rubens had a certain distance from his workshop and had functional disabilities, he appears to have further developed his later style in easel pictures. His single-handed works of the last years bear unmistakable and inimitable traces.

The first thing we can observe is that Rubens himself as good as ignored the constraints of the preparatory sketches. He chose the most direct route to the final image so that all variations and alternatives of a conception could be carried out on the original work itself. This is indicated by the frequent signs of second thoughts which over the course of time have become visible to the naked eye.

Whole groups of figures — in the *Castle at Steen, Autumn* (color plate 20), for example, a whole group of hunters in the foreground — or whole architectural features — in *Bathsheba* (color plate 13), for example, a whole section of a palace — are eliminated or rearranged. With an active urge to revise, Rubens tried to continue to work on earlier pictures (cf. fig. 56) and to correct earlier solutions in later engraved copies. Again and again he expanded works in progress: large wooden panels were added to the *St. Cecilia* (fig. 76) as well as to the *War and Peace* in London (fig. 66). Two stages of expansion have been determined in the *Offering to Venus* (fig. 77), each of which completely restructured the work as a whole. The landscape with the Castle at Steen (color plate 20) finally grew to its present form as not less than 15 additional panels were added to a two-panel nucleus. Not infrequently Rubens began completely anew: three single-handed versions exist of the *Conversation à la Mode* (color plate 14), and there are two studio copies and one larger version from his own hand of the *Harvest Landscape with Rainbow* (color plate 18). Three versions of the landscape at the Pitti Palace (fig. 80), some of them certainly from his own hand, were on the market. Rubens had almost all of his pictures reproduced by excellently trained engravers, an indication that he remained concerned about the spread of his inventions.

The color in the late works conforms to all of the movement evident in the articulation of the composition. The flesh tones can once again be glazed, though now also over rose tones so that the skin has a transparent and extremely sensitive appearance; in contrast, the colors in the robes or the landscapes are applied thickly and directly. The colors, which have become much more fluid, are generously drawn on over a bright, polished chalk base with a personal, almost graphic signature. Much of this technique is adopted from Titian paintings, though their airy, lucid application follows completely individualistic axioms. Just as in the early days in Antwerp, color values again emerge singly, no longer, however, as properties of object-bound qualities, but rather as complex, manifold color relationships set in relief, often flashing out individually. This isolation of single colors does not ensue from thematic considerations but specifically differentiates itself form these. In the *Massacre of the Innocents* (fig. 71), which is so brutal thematically, the color gradation develops an aesthetic offering which is so differentiated and radiant that the horror can thereby be dispelled. In the Berlin

82 *The Judgment of Paris* (cf. color plate 21). 1639.

Andromeda, also one of the later works (fig. 74), the luminous red cloak is removed to the lower right-hand corner, where it displays a tone all its own, independent of events in the picture. In the *St. Cecilia* (fig. 76), who herself receives music from above, a scintillating, synesthetic color musicality plays from the robe segment below her knees. Helena in her furs (fig. 75) strides on the terrace over a glowing red rug toward an equally red pillow, and in the picture of *Bathsheba* (color plate 13), the red spreads out on the left and just barely coils around beneath her black drape with a glowing effect.

Contemporaries liked to cite the *Judgment of Paris* (fig. 82, color plate 21) as an example of the ancients' opinion of an unfalsified, natural judgment. The simple shepherd was appointed by the gods as judge over the three chief goddesses, who had been forced into a beauty competition. But Paris had first shrewdly enquired after the prize with which each of the goddesses would reward him if they were to win. Juno promised power; Minerva, fame in battle; Venus, the most beautiful woman, Helena. Rubens placed Paris by a tree in the thinker's pose; Mercury holds the golden apple before him, which he is to present to the most beautiful. The cardinal-infante Ferdinand commended the picture to the Spanish king with the comment that the Venus was a "well-captured likeness of Rubens' own wife, who is one of the most beautiful women here." Paris'

169

decision in favor of Venus was a decision against power and fame in battle. The choice of Venus was not only inevitable because she was more beautiful than the others, but because she knew how to present herself to better advantage since she employs the color of her luminous red robe, which has slipped down around her hips, as an irresistible signal. Instead of power and battle, Paris also chooses artistically staged reality.

Appendix

Texts by Rubens on Art

1 Palace Construction

"We see how the architectural style called barbaric or gothic is becoming more and more obsolete and is vanishing here. We she how a few outstanding minds are introducing proper symmetry in accordance with the rules of the ancient Greeks and Romans. This does honor to and beautifies the home-land. Examples of this are the magnificent temples decorated with frescoes of the venerable Jesuit order in Brussels and Antwerp. Above all, the dignity of service to God merits our devotion to better things. Yet we should not neglect private architecture, which on the whole constitutes the city's physiognomy, especially since the convenience of buildings is almost always in harmony with their beauty and fine form.

"To me it appears worthwhile to publish the drawings of a few palaces in the magnificient city of Genoa for the appro-priate readers in all countries this side of the Alps. These I have collected on a journey through Italy. Since the noble-man reigns in the republic of Genoa, his houses are very beautiful and comfortable. They are more suited to a single noble family — even though it might be large — than to the household of a ruling prince. Examples of this type are the Pitti Palace in Florence, the Farnese Palace in Rome, the

Chancellery, Caprarola, and a multitude of other palaces in Italy, as well as the famous palace of the Queen Mother on the outskirts of Paris at Saint-Germain [Luxembourg]. The size, layout, and costliness of all of these exceeds the wealth of an independent nobleman. I wish to serve the general good, preferring to give much pleasure than a little and for this reason make the following distinction: I specify that the construction of a prince's palace have a central courtyard encircled by its buildings, the kind of construction which can accommodate a whole princely household. In contrast to this palace, a construction consisting of only one single building with a central banqueting hall [*salone*], which is divided into various rooms leading into one another that do not receive light from the center, I call a private house, no matter how large and beautiful it might be. This is how most Genoese palaces are arranged."

(From the forward to Rubens' *Palazzi di Genova*, 1622, after Cornelius Gurlitt's translation in his 1924 edition of the book, published in Berlin.)

2 On Urban Construction
"There is nothing significant here except that a fire broke out in Santvliet which a strong north wind spread so violently that in a short time the whole cavalrymen's quarter, including all the soldiers' barracks and the greater part of the town, was laid to ashes. Yet the merchants incurred losses not only from the fire, but through the looting of the soldiers who had pretended to be helping them salvage their wares. Nonetheless, as catastrophic as this fire was for individuals, it will certainly contribute to the beautification of the town since there is room now to redesign the streets and blocks with an eye to practicality and good proportion."

(Rubens to Pierre Dupuy, March 16, 1628.)

"For some painters the imitation of ancient statues is very useful; for others it is so damaging that their own art is ruined by it. Disregarding the latter, I maintain that having a knowledge of ancient art and even being completely imbued with it is essential for the greatest perfection in painting. At the same time, however, I also regard as essential the careful consideration of its application, lest the painting convey the flavor of stone. For there are unwitting, nay even skilled painters who can distinguish neither the material from the form, the stone from the figure, nor the marble's constraints on the artist from art.

"This much is true: the most beautiful statues are as useful as the worst are useless and even damaging. There are young painters who believe they have made great progress in their art when they have habituated themselves in these figures to I do not know what sort of hardness, stiffness, crudeness, and, in anatomy, laboriousness. Through these efforts alone, they make a mockery of nature, because, instead of imitating flesh, they represent nothing more than marble painted in different colors. For, particularly in the most beautiful statues, there are many details to note, or rather to avoid, without these arising from error on the artist's part. These consist primarily in gradation in shading, since the translucent quality of the flesh, skin, and cartilage teaches us to soften the hardness of the outlines, if I may use this term, and to avoid most sharp edges. The latter are caused by the black shadows which the obscurity of the already opaque stone makes still harder and more opaque. In addition, certain parts change with each and every moment and, due to the flexibility of the skin, are sometimes smooth and distended, but sometimes wrinkled and compressed. Truly, sculptors have carefully avoided such factors, and only the most skillful of them do not completely disregard them. In painting, however, they are absolutely essential, but they still must be employed with restraint. For not only are the statues' shadows completely different from those in nature, but their highlights as well; and this is all the more true since the luster of the stone, the surface of which is more than important, and the sharpness of the daylight shining upon it emphasize or at least make visible things which should not be there.

"Whoever is capable of distinguishing all of these factors with a mature discriminatory power can neither pay too close attention to nor examine too thoroughly the statues of antiquity. For in our mistaken century we are completely incapable of producing anything similar, either because a base, insinuating genius restrains us and prevents us from reaching the same heights the ancients did through their insight and their truly heroic spirit; or because we are still veiled in the darkness in which our ancestors lived; or because God permits us, after having overlooked the opportunity, to free ourselves from the mistakes which drove us into even worse mistakes; or also because such irreparable damage has been done that our spirits are weakening and the world is feeling its age; or finally, because in former centuries, insofar as the human body ws closer to its origins and its perfection, there were perfect models who represented all the unaffected beauties which we nowadays no longer find in nature. Perhaps perfection, which used to be whole, has been divided and weakened by the vice which pursues it unnoticed, so that this corruption has reached such a level that bodies of the present day no longer appear like those of the past. We could also draw this conclusion from the writings passed down by both holy and secular scribes. When they speak of the former greatness of man, they talk about heroes, giants, and cyclopses. Though they make many references to fiction, undoubtedly a little truth seeps in at the same time.

"But the main reason why the human body in our day differs from that in antiquity is our indolence, idleness, and now uncommon practice of physical fitness. For most people's bodies are fit only insofar as they can eat and drink well. When we pile more fat on top of fat we can hardly wonder that we have overflowing bodies, weak and puny legs, and arms which advance only their own idlenss. By contrast, the people of antiquity exercised daily in the academies and other places designated for physical exercise, exerting themselves until they perspired and were completely exhausted. In Mercurialis' writings on physical fitness we read about their various training procedures and the strength they needed to perform them. These forms of gymnastics were truly the best means of slimming down those areas which through indolence had become weak and fat; their paunches

disappeared and all moving parts were transformed into flesh and strengthened muscles. For the arms, legs, neck, shoulders, and all working extremities gain more strength through Nature's assistance, which, thanks to her warmth, attracts a moisture that sustains them; they thrive and grow extraordinarily like the muscles on the Negro's back, on the fencer's arms, on the dancer's legs, and like those to be seen on any oarsman's body."

(This text, which was probably written between 1630 to 1640, has been handed down by Roger de Piles in his *Cours de Peinture par Principes.* [Paris, 1708.] This translation is based on the German edition, *Einleitung in die Malerei aus Grundsätzen,* Leipzig, 1760, pp. 109-117.)

III. DESCRIPTION OF AN ANCIENT FRESCO DISCOVERED IN 1604 (cf. fig. 83)

"The bride is covered in a very long white, somewhat yellowish robe, which covers her from head to toe. Her demeanor is pensive and melancholy. The maid of honor is half-naked and shown in a violet drape; the nuptial bed is adorned with some decoration. If I remember correctly, nearby, but standing somewhat to the side, is an old woman who appears to be a servant and who holds a *scaphio* and a little basket, perhaps for the bride's use. And the more I think about it, I recall that the majority of antiquarians in Rome regarded the half-naked young man crowned with flowers as the groom who, full of impatience, glances longingly at the bride and listens to the women speak. Concerning the three women who are making offerings, two of them are wearing radiant crowns on their head and, if I remember correctly, the third has a miter. I am not certain about anything concerning them but they must be the patron goddesses of marriage and generation. Perhaps one of them is Queen Juno, although I have never seen her represented with such a crown; the other one might be Lucina 'as the rays evidently signify light, and Luna herself receives her brilliance from the rays of the sun.' "

(Rubens to Nicolas-Claude Falori de Peiresc, May 19, 1628.)

83 *The Aldobrandinian Marriage*. About 325 B.C. (discovered in 1604).

IV. ESTABLISHMENT OF THE PRICES FOR SOME PAINTINGS TO BE EXCHANGED
FOR A COLLECTION OF ANCIENT PIECES

"I learned from your letter that Your Excellency has changed
your mind in part, since you wish to have paintings for only half
the value of the marble pieces and tapestries and cash for the
other half. . . . This change seems to be due to Your Excellen-
cy's having found too few original paintings on my list, for Your
Excellency has only selected those originals with which I have
expressed my own complete satifaction. Yet Your Excellency
must not think that the others are mere copies, since they have
been so well retouched by my hand that they can hardly be
distinguished from the originals. Nevertheless, I had lowered
their prices quite considerably. I do not wish to mislead Your
Excellency with fine words, because, in the event that you stand
firm, I can still furnish originals for the stated sum. . . . The
reason why I prefer to pay in paintings is clear, for, although
they do not exceed the price stated in the list, they still cost me
nothing, so to speak. Everyone is more generous with the fruits

178

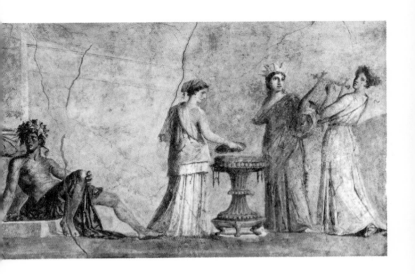

of his own garden than with those he must purchase at the market. Besides, this year I have invested several thousand guilders in the construction of my house, and I do not wish to exceed the limits of prudent economy on a whim. In truth, I am not a prince, but one who lives by the work of his hands. For this reason, if Your Excellency wishes to have paintings for the entire sum, whether they are originals or well-retouched copies (which are worth more than their price), I would meet you generously and leave the assessment of their value to any judicious person."

(Rubens to Dudley Carleton, June 1, 1618.)

V. EFFORTS TO OBTAIN ENGRAVING PRIVILEGES IN HOLLAND

"Now I need your advice. I would like to know what steps I must take to obtain a privilege from the Estates-General which would allow me to publish certain copper engravings which were

completed in my house in order to prevent them from being copied in these provinces. I have been advised by many people to procure such authorization, but, since I am an uninformed novice in these matters, I would like to hear your opinion on whether such a privilege is necessary, and whether it has the prospect of being respected in such a free country. I would like to know what steps I must take to obtain it and if this will pose great difficulties."

(Rubens to Pieter van Veen, January 4, 1619.)

1 The Problems with the Medici Cycle

"I am a bit disturbed about my personal affairs, which must certainly be suffering due to public events. Since, in light of the urgency of public matters, I can scarcely make any requests without risking the danger of tiring the Queen with my personal affairs . . . I am certain that the Queen Mother is quite satisfied with my work, as she herself has often told me so and has also repeated it to everyone. The King has also honored me with a visit to our gallery. This was the first time he entered the palace, the construction of which began 16 or 18 years ago. As all who were present reported to me, His Majesty seemed to be completely satisfied with our paintings. In particular, M. de St. Ambroise, who served as interpreter of the subjects, assured me of this by quite skillfully changing or veiling the true meaning. I think I have written to you that a picture portraying the Queen's departure from Paris was removed. To replace it, I have painted an entirely new picture, which portrays the happy regency of the Queen. It illustrates the flowering of the kingdom of France, the revival of the sciences and the arts due to the liberality and magnanimity of Her Majesty, who, seated on a shining throne, holding a scale in her hand, thus maintains equilibrium in the world through her wisdom and justice. This subject, which is no ways touches upon the political reason of this reign or refers to any particular individual, has attracted many friends, and I believe that if I had also been entrusted

with the other subjects, they would have passed by the court without any scandal or murmur. Cardinal Richelieu recognized this too late, and he was quite irritated that the new subjects were so misunderstood. I believe that in the future the subjects of the other gallery will also meet with difficulties. For this reason, the subjects should be light and raise no second thoughts. The spectrum of themes is so broad and splendid that it would be adequate for ten galleries. However, Monsignor Cardinal Richelieu, whom I have given a short written program, is so burdened with affairs of state that he still has not found time to even read it once. . . . In short, I find this court tedious, and if I am not given the same punctual satisfaction which I have observed in my service to the Queen Mother, then it might happen (though I say this in confidence, between us two) that I will never return. Despite everything though, to be honest, I cannot complain about Her Majesty's behavior, as the difficulties were justifiable and excusable. But, in the meantime, time passes and I am far away from home, a fact which has disadvantaged me greatly."

(Rubens to de Peiresc, May 13, 1625.)

2 On the Ceiling Paintings for Whitehall (fig. 45)
 "Since courts are an abomination to me, I have had a third party send my pictures to England. They have now reached their destination, and my friends write that His Majesty is completely satisfied with them. I still haven't received payment for them, however, which would surprise me if I were a novice in the ways of the world. But since years of experience have taught me how slowly princes act in matters of others' interests, and how much easier it is for them to do ill than good, I have as yet not undertaken anything . . ."

(Rubens to de Peiresc, March 16, 1636.)

3 On an Allegory of Diplomacy (fig. 84)
 "Politica or the Art of proper governing is in the middle. The square base signifies the solidity of the state. Like

LEGATVS
FREDERICI DE MARSELAER
EQVITIS, TOPARCHÆ DE PARCK.CONS.BRVX.
AD
PHILIPPVM IV.
HISPANIARVM REGEM.
Editio Secunda,
ab ipso Auctore
aucta et recensita.

ANTVERPIÆ,
EX OFFICINA
PLANTINIANA.
M.DC.LXVI.

84 Title page for *Frederik Marselaer, Legatus*. 1638, after the sketch by Rubens, engraved by Cornelis Galle the Younger.

Cybele, she is crowned with towers, because she builds the cities, governs, and upholds. Poppies and shafts of grain are woven in her hair, because she sustains the people and guarantees her citizens a secure tranquility.

"To her right stands Minerva, goddess of wisdom, because the virginal figure sprung from Zeus' brow shines with intelligence. She reaches her right hand out to Mercury, and sanctifies the friendship, since he, Hermes, is the spokesman and messenger of the gods, master of eloquence and verbal persuasion. He well deserves to be the patron god and chief of ambassadors, for just as he acts as messenger to the gods, so do they act as messengers to the princes who represent the gods on earth.

"The caduceus is the symbol of peace, for ambassadors are appointed to establish friendships and secure treaties rather than to dissolve them. And for this reason they are recognized as untouchable and invulnerable, even when they are sometimes assigned dolorous tasks. This is why in the Trojan War Homer portrays Mercury as the only god of them all who is knowledgeable in discourse and war. This is why the advice gleaned from Minerva's wisdom must be put into action through eloquence, through the words best suited to the issue, so that the ambassador pursues his goal and fulfills his duty with composure.

"On the pedestal under Minerva there is a wreath of olive branches which belongs to this goddess. At one time at a public assembly of all of Greece, it was awarded to Themistocles in praise of his wisdom. There is a palm branch stuck through it, since wisdom triumphs.

"The civil crown of oak leaves is under Mercury, for through the accomplishments of ambassadors (indicated by the olive branch which they bear), who judiciously conduct public affairs, the citizens are preserved.

"The play of the dancing and frolicking children, used by all of antiquity on marble pieces and coins to represent the happiness of the people, says much the same thing.

"Above, on either side of Politica, guardian angels fly, bearing good luck. One signifies victory, the other command of the earthly realm. With their encouragement one

can predict that everything will flourish within and without, that the government will thrive and endure for a long time. Similarly, the necklace in the form of a snake around Politica's neck stands for circulation, for eternity. And this type of adornment is not foreign to us either, for the Romans reproduced this image, as can be seen on Antonius Augustinus, and since I myself have seen and held in my hands such an antique necklace of astonishingly fine workmanship in the Museum of Laelius Pasqualinus in Rome.

"The cornucopia of Amalthaea, overflowing with crowns, scepters, and fruit, need no explanation; what I have already said clarifies them."

(Interpretation of his frontispiece to *Frederik Marselaer, Legatus.* Translation after the exhibition catalog *Peter Paul Rubens,* Siegen, 1967, p. 35.)

4 Explanation of the Allegory of War in the Pitti Palace (fig. 68, color plate 12)

"Concerning the subject of my painting, it is so clear that the little I told you about it recently, along with the observations made by your experienced eye, will impart more to you than my explanation. Nevertheless, to comply with your wishes I will describe the painting in a few words. The central figure is Mars, who has left the open Temple of Janus — which, according to Roman custom, remained closed during times of peace — and with his shield and bloody sword charges toward the people, threatening great harm. He pays little attention to Venus, his mistress, who, accompanied by her amoretti and cupids, attempts to hold him back with caresses and embraces. On the other side of the picture, Mars is drawn forward by the Fury Alecto, who holds a torch in her hand. Alongside, monsters stand for plague and hunger, the inseparable companions to war. A woman with a broken lute, a symbol of discord representing incongruous harmony, is lying stretched out on the ground with her back turned. Likewise, a mother holding her child

in her arms indicates that fertility, procreation, and parental love are disrupted by war, which ruins and destroys everything. In addition, there is an architect thrown on his back with his instruments in his hand, who expresses that what is built in times of peace for the use and beautification of the cities, falls to ruins and perishes by the force of arms. If I remember correctly, I believe there is a book on the ground, as well as a drawing on paper beneath the feet of Mars, which indicates that Mars treads upon science and all that is beautiful. There must also be a bundle of arrows in the picture, and the band which previously held them together is undone. When bound, the arrows are regarded as the symbol of Harmony, and the caduceus and olive branch I laid beside them are symbols of peace. That grieving woman, however, clad in black with a torn veil, robbed of all her jewels and ornaments, is the unfortunate Europe, which has endured plunder, humiliation, and misery for so many years now, so deeply felt by everyone, that I need say no more on the subject. Her symbol is the globe which is borne by a little angel or genius with the cross overhead signifying the Christian world."

(Rubens to Justus Sustermans, March 12, 1638.)

Suggested Reading

BIBLIOGRAPHIES

Arents, P. *Geschriften van en over Rubens*. Antwerp, 1940.
Arents, P. *Rubens-Bibliographie*. Brussels, 1943.

SOURCES

Rooses, M., and Ruelens, Ch. *Correspondance de Rubens et Documents Épis-
tolaires concernant sa vie et ses oeuvres*. 6 vols. Antwerp, 1887–1909.
Die Briefe des P.P. Rubens. Translation and introduction by O. Zoff. Vienna,
1918.
Rubens, Peter Paul. *Palazzi di Genova* (1622). Edited by H. Gurlitt. Berlin,
1924.
Lind, L.R. "The Latin Life of Peter Paul Rubens by his Nephew Philip. A
Translation." *The Art Quarterly* 9 (1946):37–43.
Rubens, Peter Paul. *The Letters of Peter Paul Rubens*. Translated and edited by
R.S. Magurn. Cambridge, Mass., 1955.

CATALOGS

Rooses, M. *Rubens*. Translated by Harold Child. 2 vols. Philadelphia, 1904.
Oldenbourg, R. *P.P. Rubens. Des Meisters Gemälde*. Klassiker der Kunst, vol.
5. 4th ed. Stuttgart-Berlin, 1921.
Corpus Rubenianum Ludwig Burchard. Brussels, 1968–. (26 volumes are
planned; vols. 1, 8, 9, 10, 16 have been published up to 1977.)

SURVEY WORKS

Oldenbourg, R. *Peter Paul Rubens*. Edited by W. von Bode. Munich, 1922.
Evers, H. G. *Peter Paul Rubens*. Munich, 1942.
Burckhardt, J. *Recollections of Rubens*. London, 1950.
Baudouin, F. *Rubens et son Siècle*. Antwerp, 1972.

DRAWINGS AND ENGRAVINGS

Glück, G., and Haberditzl, F. M. *Die Handzeichnungen des Peter Paul Rubens*. Berlin, 1928.

Van den Wijngaert, F. *Inventaris der Rubeniaansche Prentkunst*. Antwerp, 1940.

Held, J. *Rubens, Selected Drawings*. 2 vols. London, 1959.

Burchard, L., and d'Hulst, R. A. *Rubens Drawings*. 2 vols. Brussels, 1963.

Rosand, D. "Rubens Drawings" (Research report). *The Art Bulletin* 48 (1966):234-247.

Bernhard, M. *Peter Paul Rubens. Handzeichnungen*. Munich, 1977.

Rubens in der Grafik. Exhibition catalog. Göttingen, 1977.

OIL SKETCHES

Haverkamp-Begemann, E. *Olieverschetsen van Rubens*. Exhibition catalog. Rotterdam, 1953/4.

van Puyvelde, L. *Les Esquisses de Rubens*. Basel, 1958.

Müller-Hofstede, J. "Aspekte der Entwurfszeichnung bei Rubens." *Akten des 21. Internationalen Kongresses für Kunstgeschichte in Bonn 1964*. Berlin, 1967. vol. 3:114-125.

VARIOUS ASPECTS OF HIS LIFE AND WORK

Bock von Wülfingen, O. *Rubens in der deutschen Kunstbetrachtung*. Berlin, 1947.

van Gelder, J. G. "Rubens in Holland in de zeventiende Eeuw." *Nederlands Kunsthistorisch Jaarboek* 3 (1950/51):103-150.

Baudouin, F. *Rubens Diplomate*. Exhibition catalog. Antwerp, 1962.

Teyssèdre, B. "Une Collection Française de Rubens au XVII^e Siècle: Le Cabinet du Duc de Richelieu décrit par Roger de Piles (1676-1681)." *Gazette des Beaux-Arts* 62 (1963):242-299.

Jaffe, M. "Rubens and Raphael." *Studies in Renaissance and Baroque Art Presented to Anthony Blunt*. London-New York, 1967. 98-107.

Müller-Hofstede, J. "Rubens und Tizian: Das Bild Karls V." *Münchner Jahrbuch der bildenden Kunst* 18 (1967):33-96.

Stechow, W. *Rubens and the Classical Tradition*. Cambridge, Mass., 1968.

Jaffe, M. "Rubens and Optics." *Journal of the Warburg and Courtauld Institutes* 34 (1971):363-366.

FURTHER READING ON INDIVIDUAL WORKS REFERRED TO IN THIS VOLUME

Kauffmann, H. "Rubens und Isabella Brant in der 'Geissblattlaube'." *Form und Inhalt. Festschrift für O. Schmitt*. Stuttgart, 1950. 257-274. (cf. color plate 1)

Schöne, W. *Peter Paul Rubens: Die Geissblattlaube.* Reclams Werkmonographien, no. 11. Stuttgart, 1956.

Konrad, M. "Antwerper Binnenräume im Zeitalter des Rubens." P. Clemen, *Belgische Kunstdenkmäler.* Vol. 2. Munich, 1923. 234-239. (On the Rubens House)

Prims, F. *Het Rubenshuis.* Antwerp, 1947. (cf. fig. 19)

Monballieu, A. "Bij de iconografie van Rubens' Rockox-epitafium." *Jaarboek van het Koninklijk Museum voor Schone kunsten Antwerpen.* 1970. 133-155. (cf. fig. 31).

Prinz, W. "The 'Four Philosophers' by Rubens and the Pseudo-Seneca in Seventeenth-Century Painting." *The Art Bulletin* 50 (1973):410-428. (On the Philosophers' Picture in the Pitti Palace; cf. fig. 21)

Glück, G. "Rubens' Kreuzaufrichtungsaltar." P. Clemen: *Belgische Kunstdenkmäler.* Vol. 2. Munich, 1923. 161-184. (cf. fig. 26)

Heiland, S. "Two Rubens Paintings Rehabilitated." *The Burlington Magazine* 111 (1969):421-427. (On the predella of the *Elevation of the Cross*)

Martin, J. R. *Rubens — The Antwerp Altarpieces. The Raising of the Cross and the Descent from the Cross.* London, 1969.

Bialostocki, J. "The Descent from the Cross in Works by Rubens and His Studio." *The Art Bulletin* 46 (1964):511-524. (cf. fig. 29, color plate 2)

Alpers, S. L. "Manner and Meaning in some Rubens Mythologies." *Journal of the Warburg and Courtauld Institutes* 30 (1967):272-295. (On *Castor and Pollux Seizing the Daughters of Leucippus*, cf. color plate 5)

Smith, G. "Rubens' Altargemälde des Hl. Ignatius von Loyola and des Hl. Franz Xaver für die Jesuiten-Kirche in Antwerpen." *Jahrbuch der Kunsthistorischen Sammlungen Wien* 65 (1969):39-60. (cf. figs. 45 and 46)

Norris, Ch. "Rubens' *Adoration of the Kings* of 1609." *Nederlands Kunsthistorisch Jaarboek* 14 (1963):120-136. (cf. fig. 56)

Müller-Hofstede, J. "Rubens' St. Georg und seine frühen Reiterbildnisse." *Zeitschrift für Kunstgeschichte* 28 (1965):69-112. (cf. fig. 54)

Rosand, D. "Rubens' Munich *Lion Hunt*: Its Sources and Significance." *The Art Bulletin* 51 (1969):29-40. (cf. fig. 59)

Coolidge, J. "Louis XIII and Rubens: The Story of the Constantine Tapestries." *Gazette des Beaux-Arts* 67 (1966):271-291. (cf. fig. 61)

Thuillier, J. "La *Gallerie de Medicis* de Rubens et sa genese: un document inédit." *Revue de L'Art* 3 (1969):52-62.

189

Thuiller, J. *Rubens' Life of Marie de Medici*. Translated by Robert Erich Wolf. New York, 1970. (cf. color plate 11)

Vetter, E. M. "Rubens und die Genese des Programms der Medici-Galerie." *Pantheon* 32 (1974):355-373.

Jost, J. "Bemerkungen zur *Heinrichsgalerie* des P. P. Rubens." *Nederlands Kunsthistorisch Jaarboek* 15 (1964):175-219. (cf. fig. 63)

Millar, O. *Rubens — The Whitehall Ceiling*. London, 1958. (cf. fig. 65)

Baumstark, R. "Ikonographische Studien zu Rubens *Kriegs- und Friedensallegorien*. *Aachener Kunstblätter* 45 (1974):125-234. (cf. figs. 66-68, color plate 12)

Held, J. S. "Rubens' *Het Pelsken*. *Essays in the Honor of Art Presented to R. Wittkower*. London, 1967. 188-192. (cf. fig. 75)

Klessmann, R. "Rubens' *Saint Cecilia* in the Berlin Gallery after Cleaning." *The Burlington Magazine* 107 (1965):550-559. (cf. fig. 76)

Glück, G. "Rubens' *Liebesgarten*. *Jahrbuch der Kunsthistorischen Sammlungen in Wien* 35 (1920):49-98. (cf. color plate 14)

Burchard, W. "The Garden of Love by Rubens." *The Burlington Magazine* 105 (1963):428-432.

Swoboda, K. M. "Des Rubens *Venusfest* in der Wiener Gemäldegalerie." K.M.S., *Kunst and Geschichte*. Mitteilungen des Instituts für Osterreichische Geschichtsforschung. Supplementary vol. 22. Vienna-Cologne-Graz, 1969. 213-226. (cf. fig. 77)

Fehl, Ph. "Rubens' *Feast of Venus Verticordia*. *The Burlington Magazine* 114 (1972):159-162.

Glück, G. *Die 'Landschaften' von Peter Paul Rubens*. 2d. ed. Vienna, 1945. (cf. figs. 42 and 80, color plates 18-20)

List of Color Plates

1. *Rubens and Isabella Brant under the Honeysuckle Bower.* 1609-1610. Oil on canvas, 178 × 135 cm. Munich, Alte Pinakothek.
2. *The Descent from the Cross* (central panel of the triptych). Antwerp 1611-1614. Oil on wood, 420 × 310 cm. Antwerp Cathedral.
3. *Christ and the Repentant Sinners.* Ca. 1618. Oil on wood, 147 × 130 cm. Munich, Alte Pinakothek.
4. The Small *Last Judgment.* Ca. 1620. Oil on wood, 183 × 119 cm. Munich, Alte Pinakothek. (detail; cf. fig. 39)
5. *Castor and Pollux Seizing the Daughters of Leucippus.* Ca. 1618. Oil on canvas, 222 × 209 cm. Munich, Alte Pinakothek.
6. *The Battle of the Amazons.* Ca. 1616-1618. Oil on wood, 121 × 165 cm. Munich, Alte Pinakothek.
7. *The Battle of the Amazons.* Ca. 1616-1618. Oil on wood, 121 × 165 cm. Munich, Alte Pinakothek. (detail; cf. color plate 6)
8. *The Prodigal Son.* Ca 1617-1618. Oil on wood, 107 × 155 cm. Antwerp, Royal Museum of Fine Arts. (detail; cf. fig. 41)
9. *The Crucifixion ("Le Coup de Lance").* 1620. Oil on wood, 429 × 311 cm. Antwerp, Royal Museum of Fine Arts.
10. *Adoration of the Kings.* 1624. Oil on wood, 447 × 336 cm. Antwerp, Royal Museum of Fine Arts. (detail; cf. fig. 49)
11. *Henry IV Receiving the Portrait of Maria Medici.* Ca. 1622-1625. Oil on canvas, 394 × 295 cm. Paris, Louvre.
12. *The Horrors of War.* 1637-1638. Oil on canvas, 206 × 342 cm. Florence, Pitti Palace. (detail; cf. fig. 68)
13. *Bathsheba at the Fountain.* Ca. 1635. Oil on wood, 175 × 126 cm. Dresden, State Picture Gallery.
14. *Conversation à la Mode.* Ca. 1633. Oil on canvas, 198 × 283 cm. Madrid, Prado.

15. *The Three Graces*. Ca. 1639. Oil on wood, 221 × 181 cm. Madrid, Prado. (detail; cf. color plate 15)
16. *The Three Graces*. Ca. 1639. Oil on wood, 221 × 181 cm. Madrid, Prado. (detail; cf. color plate 15)
17. *The Rondo* (Dance of Italian Peasants). Ca. 1633. Oil on wood, 73 × 101 cm. Madrid, Prado.
18. *Harvest Landscape with Rainbow*. Ca. 1635. Oil on wood, 92 × 118 cm. Munich, Alte Pinakothek.
19. *Harvest Landscape with Rainbow*. Ca. 1635. Oil on wood, 92 × 118 cm. Munich, Alte Pinakothek. (detail; cf. color plate 18)
20. *The Castle at Steen, Autumn*. 1636. Oil on wood, 131.8 × 229.9 cm. London, National Gallery.
21. *The Judgment of Paris*. 1639. Oil on wood, 199 × 379 cm. Madrid, Prado. (detail; cf. fig. 82)

LIST OF ILLUSTRATIONS

1. *A Loving Couple (Knight and Lady)*. After an engraving by Israel van Meckenem. Before 1600. Pen and ink, 19.9 × 13.9 cm. Berlin (West), State Museums, Collection of Copper Engravings.
2. Andrea Alciatus: *Emblemata*. Lyon 1551 (1st ed. 1522). Emblem CXC. Woodcut after a drawing by Bernard Salomon.
3. *Pausias and Glycera* (Flowers by Osias Beert). Ca. 1613. Oil on canvas, 235 × 195 cm. Sarasota, Fla., The John and Mabel Ringling Museum.
4. The Front of the Triumphal Arch of Philip (engraved by Theodor van Thulden after Rubens' model). 1635. Antwerp.
5. *Portrait of a Couple with a Child*. Ca. 1609. Oil on canvas, 116 × 112.5 cm. Karlsruhe, State Art Gallery.
6. *Portrait of a Child* (probably Nicolas Rubens). Ca. 1619. Pen and red, black, and white chalk, 25.2 × 20.3 cm. Vienna, Albertina.
7. *Boy Playing with Bird*. Ca. 1616. Oil on wood, 50.8 × 40.5 cm. Berlin (West), State Museums, Picture Gallery.
8. *The Madonna Surrounded by Garland and Boy Angels* (Flowers by Jan Brueghel the Elder). Ca. 1620. Oil on wood, 185 × 210 cm. Munich, Alte Pinakothek.
9. Raphael: *Madonna with Siskin*. Ca. 1506. Oil on wood, 107 × 77 cm. Florence, Uffizi.
10. *The Artist's Sons, Albert and Nicolas Rubens*. Ca. 1626. Oil on wood, 158 × 92 cm. Vaduz, Liechtenstein Royal Collections.
11. *Isabella Brant*. Ca. 1623. Oil on wood, 85 × 62 cm. Florence, Uffizi.

12. *Helena Fourment with Her Firstborn Son Frans.* Ca. 1635. Oil on wood, 146 × 102 cm. Munich, Alte Pinakothek.
13. *Self-Portrait.* Ca. 1625. (After cleaning and restoration.) Oil on wood, 86 × 62.5 cm. Windsor Castle. Reproduced with the kind permission of Her Majesty Elizabeth II, Queen of England.
14. *Copy of Lucas van Leyden's Self-Portrait.* Ca 1630-1635. Brush with bister over black chalk, 27.9 × 20 cm. Paris, Fondation Custodia.
15. Paulus Pontius: *Portrait of Peter Paul Rubens.* 1626. Copper engraving, first position. Brussels, Royal Library of Belgium, Print Gallery.
16. *Self-Portrait.* Ca. 1628. Oil on wood, 78 × 61 cm. Florence, Uffizi.
17. *Self-Portrait.* Ca. 1636. Oil on wood, 109.5 × 85 cm. Vienna, Kunsthistorisches Museum.
18. *Self-Portrait.* Ca. 1634. Chalk, 46.1 × 28.7 cm. Paris, Louvre, Print Collection.
19. Jacques Harrewijn after J. van Croes. *View of the Courtyard at Rubens' House.* 1684. Copper engraving. Antwerp, Rubens' House.
20. *Self-Portrait.* Ca 1635-1640. Chalk. Windsor Castle. Reproduced with the kind permission of Her Majesty Elizabeth II, Queen of England.
21. *Justus Lipsius and His Pupils.* Ca. 1611. Oil on wood, 164 × 139 cm. Florence, Pitti Palace.
22. *The Death of St. Anthony Eremita.* Ca. 1615. Oil on canvas, 206 × 143 cm. Pommersfelden Castle.
23. *The Dying Seneca.* Ca. 1611. Oil on wood, 181 × 152 cm. Munich, Alte Pinakothek.
24. Jacob de Gheyn: *The Dying Seneca.* Ca. 1611-1612. Pen and brown ink, 23.3 × 18 cm. Cologne, Wallraf-Richartz-Museum, Copper Engraving Collection.
25. *The Dispute of the Holy Sacrament.* Ca. 1609. Oil on canvas, 309 × 241.5 cm. Antwerp, St. Paul's Church.
26. *The Elevation of the Cross* (middle panel of the triptych). 1610-1611. Oil on wood, 462 × 341 cm. Antwerp Cathedral.
27. Hans Baldung-Grien: *The Elevation of the Cross.* Woodcut. Illustration to: Ulrich Pinder, *Speculum Passionis Domini Nostri Ihesu Christi.* Nürnberg 1507, fol. 54r Nürnberg, Germanisches Nationalmuseum.
28. *The Gemma Augustea.* Ca. 1623. Black chalk and brown ink, 22.5 × 25.5 cm. Lübeck, St. Annen-Museum.
29. *The Descent from the Cross.* Ca. 1612. Saint-Omer Cathedral.
30. Hans Baldung-Grien: *Descent from the Cross.* Ca. 1505. Woodcut. Berlin (West), State Museums, Copper Engraving Collection.
31. *The Doubting Thomas. Christ Appearing to Thomas, Paul, and Peter* (Epitaph for Nicolas Rockox; middle panel of the triptych). Ca. 1613-1615. Antwerp, Royal Museum of Fine Arts.

32. *Venus, Ceres, Bacchus, and Cupid.* Ca. 1613. Oil on wood, 141 × 199.2 cm. Cassel, State Art Collection, Picture Gallery.
33. *Hero Crowned by Victory.* Ca. 1612. Oil on wood, 216 × 196 cm. Munich, Alte Pinakothek.
34. *Hercules Drunk.* Ca. 1612. Oil on wood, 204 × 225 cm. Dresden, State Art Collection, Picture Gallery.
35. *The Toilet of Venus.* Ca. 1613-1615. Oil on wood, 124 × 98 cm. Vaduz, Liechtenstein Royal Collections.
36. *Christ Laid in the Tomb,* after Caravaggio. About 1613-1615. Oil on wood, 88.3 × 65.4 cm. Ottawa, National Gallery of Canada.
37. Caravaggio: *Christ Laid in the Tomb.* Ca. 1602-1604. Oil on canvas, 300 × 203 cm. Rome, Pinacoteca Vaticana.
38. The Large *Last Judgment. Ca.* 1616. Oil on canvas, 610 × 460 cm. Munich, Alte Pinakothek.
39. The Small *Last Judgment.* Ca. 1620. Oil on wood, 183 × 119 cm. Munich, Alte Pinakothek. (cf. color plate 4)
40. *Perseus and Andromeda.* Ca. 1619-1620. Oil on wood, 100 × 138 cm. Berlin (West), State Museums, Picture Gallery.
41. *The Prodigal Son.* Ca. 1617-1618. Oil on wood, 107 × 155 cm. Antwerp, Royal Museum of Fine Arts. (cf. color plate 8)
42. *Landscape with Cows and Milkmaid.* Ca. 1618-1620. Oil on Wood, 81 × 106 cm. Munich, Alte Pinakothek.
43. *St. Sebastian.* Ca. 1617. Oil on canvas, 200 × 128 cm. Berlin (West), State Museums, Picture Gallery.
44. *Abraham Sacrificing Isaac.* Ca. 1620. Oil sketch on wood 50 × 65 cm. Paris, Louvre.
45. *The Miracles of St. Francis Xavier.* Ca. 1617-1618. Oil sketch on wood, 104.5 × 72.5 cm. Vienna, Kunsthistorisches Museum.
46. *The Miracles of St. Francis Xavier.* Ca. 1617-1618. Oil on canvas, 535 × 395 cm. Vienna, Kunsthistoriches Museum.
47. Otto van Veen: *Quinti Horati Flacci Emblemata.* Antwerp 1607, p. 79 (*Potestas Potestati Subiecta*).
48. *The Death of Decius Mus (The Battle of Veseris).* 1617. Oil on canvas, 288 × 519 cm. Vaduz, Liechtenstein Royal Collections.
49. *The Adoration of the Kings.* 1624. Oil on wood, 447 × 336 cm. Antwerp, Royal Museum of Fine Arts. (cf. color plate 10)
50. *The Assumption of the Virgin.* 1625. Oil on wood, 490 × 325 cm. Antwerp, Main Altar of the Cathedral.
51. *The Madonna Enthroned with St. Catherine and Other Saints.* Ca. 1627. Oil on wood, 79 × 55 cm. Berlin (West), State Museums, Picture Gallery.
52. *Portrait of Hendrik van Thulden.* Ca. 1616. Oil on wood, 121 × 104 cm. Munich, Alte Pinakothek.

53. *Portrait of Gaspar Gevartius.* Ca. 1628. Oil on wood, 119 × 98 cm. Antwerp, Royal Museum of Fine Arts.

54. *The Duke of Lerma on Horseback.* 1603. Oil on canvas, 283 × 200 cm. Madrid, Prado.

55. L. Gaultier: Frontispiece for Antoine de Bandole, *Les vies parallèles de César et de Henry IV.* Paris 1609. Copper engraving. Paris, Bibliothèque Nationale.

56. *The Adoration of the Kings.* 1609 (retouched 1628). Oil on canvas, 346 × 488 cm. Madrid, Prado.

57. *Hero Crowned by Victory (The Victor's Triumph).* Ca. 1613. Oil on wood, 159 × 236 cm. Cassel, State Art Collections, Picture Gallery.

58. *Tree Felled by a Storm.* Ca. 1617-1618. Black chalk and ink, 58.2 × 48.9 cm. Paris, Louvre, Drawing Collection.

59. *The Lion Hunt.* Ca. 1621. Oil on canvas, 246 × 374 cm. Munich, Alte Pinakothek.

60. Follower of Jan Scorel: *Lion Hunt* (detail). Woodcut. Berlin (West), State Museums.

61. *The Vision of the Monogram of Christ.* Ca. 1622-1623. Oil on wood, 45 × 55 cm. Philadelphia, Museum of Art.

62. *The Madonna Adored by St. Gregory and Other Saints.* 1607. Oil on canvas, 447 × 286 cm. Grenoble, Museum of Fine Arts.

63. *The Capture of Paris by Henri IV.* 1627-1631. Oil sketch on wood, 24 × 45 cm. Berlin (West), State Museums, Picture Gallery.

64. Rubens' Atelier: *The Victor Seizing the Opportunity for Peace.* Ca. 1630. Black chalk, 383 × 477 cm. Weimar, State Art Galleries.

65. *The Wise Government of King James I.* Ca. 1631. Oil sketch on wood, 64.5 × 47.5 cm (sketch for the ceiling paintings in Whitehall Palace, Banqueting House, London). Vienna Academy, Picture Gallery.

66. *War and Peace.* 1629. Oil on wood, 203 × 298 cm. London, National Gallery.

67. *Minerva and Hercules Battling Mars.* Ca. 1635-1637. Gouache over black chalk, 37 × 53.9 cm. Paris, Louvre, Drawing Collection.

68. *The Horrors of War.* 1637-1638. Oil on canvas, 206 × 342 cm. Florence, Pitti Palace. (cf. color plate 12)

69. *Christ Bearing the Cross.* Ca. 1636-1637. Oil on canvas, 569 × 355 cm. Brussels, Royal Museum of Fine Arts .

70. *Crucifixion of St. Peter.* Ca. 1638. Oil on canvas, 310 × 170 cm. Cologne, St. Peter's.

71. *The Massacre of the Innocents.* Ca. 1636. Oil on wood, 199 × 302 cm. Munich, Alte Pinakothek.

72. *The Rape of the Sabines.* Ca. 1636. Oil on wood, 169.9 × 236.2 cm. London, National Gallery.

73. *The Banquet of Tereus*. Ca. 1636-1637. Oil on canvas, 195 × 267 cm. Madrid, Prado.
74. *Andromeda*. Ca. 1635. Oil on wood, 189 × 94 cm. Berlin (West), State Museums, Picture Gallery.
75. *The Woman in the Pelisse* (Portrait of Helena Fourment). Ca. 1638. Oil on wood, 176 × 83 cm. Vienna, Kunsthistorisches Museum.
76. *St. Cecilia*. Ca. 1639-1640. Oil on wood, 177 × 139 cm. Berlin (West), State Museums, Picture Gallery.
77. *The Offering to Venus*. Ca. 1632. Oil on canvas, 217 × 350 cm. Vienna, Kunsthistorisches Museum.
78. *The Miracle of St. Ildefonso* (middle panel of the triptych). Ca. 1630-1632. Oil on wood, 352 × 236 cm. Vienna, Kunsthistorisches Museum.
79. *Madonna with Saints*. Ca. 1639. Oil on wood, 211 × 195 cm. Antwerp, St. James'.
80. *The Return from the Fields*. Ca. 1635. Oil on wood, 122 × 195 cm. Florence, Pitti Palace.
81. *Trees by the Water at Sunset*. Ca. 1635. Black, red, and white chalk, 27.3 × 45.4 cm. London, British Museum.
82. *The Judgment of Paris*. 1639. Oil on canvas, 199 × 379 cm. Madrid, Prado. (cf. color plate 21)
83. *The Aldobrandinian Marriage*. Ca. 325 B.C. (discovered in 1604). Fresco, 92 × 242 cm. Rome, Pinacoteca Vaticana.
84. Title page for *Frederik Marselaer, Legatus*. Copper engraving, after the sketch by Rubens (1638), engraved by Cornelius Galle the Younger. Antwerp, Plantin-Moretus Museum.

Photographic Credits

Antwerp, Plantin-Moretus Museum: fig. 84
Antwerp, Rubens' House: fig. 19
Berlin, State Museums: figs. 1, 30, 40, 43, 74, 76
Brussels, A.C.L.: color plate 2; figs. 25, 26, 31, 50, 69, 79
Brussels, Royal Library: fig. 15
Dresden, Deutsche Fotothek: color plate 13; fig. 34
Gaunting near Munich, Joachim Blauel: color plates, 1, 3, 4, 5, 6, 7, 18, 19; fig. 39
Cassel, State Art Collections: fig. 32
Cologne, DuMont Publishing Archives: figs. 12, 65
Cologne, Rhenish Picture Archives: figs. 24, 70
Karlsruhe, State Art Gallery: fig. 5
London, British Museum: fig. 81
London, National Gallery: color plate 20; figs. 66, 72
Lübeck, St. Annen-Museum: fig. 28
Madrid, Prado: color plates 14, 15, 16, 17, 21; fig. 82
Marburg, Archives of the Author: figs. 2, 4, 14, 22, 23, 29, 44, 47, 51, 54, 57, 60, 74
Marburg, Foto Marburg: figs. 6, 7, 11, 16, 17, 18, 21, 35, 48, 56, 58, 59, 62, 63, 67, 73, 75, 80
Munich, Bavarian State Picture Collection: figs. 8, 33, 38, 42, 52, 71
Nürnberg, Germanisches National Museum: fig. 27
Ottawa, National Gallery of Canada: fig. 36
Paris, Bibliothëque Nationale: fig. 55
Paris, Photographie Giraudon: color plates 8, 9, 10, 12; figs, 9, 41, 49, 53, 68
Paris, Photographic Documentation Service of the Union of National Museums: color plate 11
Philadelphia, Museum of Art: fig. 61
Rome, Arte fotographica: figs. 37, 83
Sarasota, Fla., John and Mabel Ringling Museum of Art: fig. 3
Vaduz, Liechtenstein Royal Collections: fig. 10
Weimar, State Art Collections: fig. 64
Vienna, Kunsthistorisches Museum: figs. 45, 46, 77, 78
Windsor, Royal Library: figs. 13, 20

In light of an oeuvre of about 3,000 works, it is natural that the Rubens works cited in this section (Rubens' works *only* are *in italics*) only cover a selection of the most important ones. Those mentioned are mainly the works reproduced in this volume.

1577 Peter Paul Rubens is born on June 28 in Siegen (Westphalia), the son of Jan Rubens, a Calvinist lawyer from Antwerp living in exile because of religious beliefs, and his wife Maria, née Pypelinkcs.

 1577: Francis Drake, English seafarer and "Queen's Pirate," undertakes a voyage around the world, the second in history. — In Rome the oldest painting academy extant, the Accademia di San Luca, is founded.

1578 The Rubens family moves to Cologne after Jan Rubens served for ten years as legal counselor to the duchess Ann of Saxony, the wife of William I. Subsequently, Peter Paul has his first instruction in Cologne.

 1578-1586: Adam Elsheimer is born (1578). — The seven northern provinces of the Netherlands join together under William of Orange against Spain in the Union of Utrecht; the Walloon provinces return to Catholicism; Frans Snyders is born (1579). — Philip II forcibly takes possession of Portugal for the Spanish crown; Portugal's colonies fall to

Spain, the Netherlands, and England; Frans Hals is born; Andrea Palladio dies (1580). — The Calvinist north Netherlands under William of Orange renounce Spain completely and form the United Provinces of the Netherlands; the southern provinces are unable to withdraw from Spanish control (the Spanish Netherlands); Bernardo Strozzi and Domenichino are born (1581). — The Gregorian calendar is introduced, into first the Catholic, then the Protestant countries; David Teniers the Elder and Giovanni Lanfranco are born (1582). — The Elzevier Dutch Printing House is founded; Galileo makes his first observations on the pendulum; Wallenstein and the Dutch legal scholar Hugo Grotius are born (1583). — The Dutch governor, William of Orange is murdered by a Catholic; Sir Walter Raleigh starts the first settlements in what is to become Virginia; the potato is introduced to Europe (Ireland, 1584). — The eighth Huguenot war of the Catholic League begins, led by King Henri III of France; war breaks out between England and Spain; Richelieu is born; Shakespeare comes to London; van Coninxloo founds the Frankenthal School of painting; sometime around this year delftware grows out of the imitation of Chinese porcelain; Antwerp loses its position in world commerce to Amsterdam and Rotterdam (1585). — Galileo invents the hydrostatic scale; tobacco smoking is introduced to England by the Virginia colonists; El Greco paints "The Burial of Count Orgaz" (1586).

1587 Jan Rubens dies after again becoming a Catholic and is buried in St. Peter's, Cologne.

1587-1588: The Catholic queen of Scotland, Mary Stuart, is executed; in Venice the first public clearing bank is created (1587). — The Spanish Armada is devastatingly defeated and sunk in the sea battle against the English fleet under Francis Drake; thus ends the Spanish era of dominance on the sea, and the English era begins; King Henri III changes over from the Catholic League to the Huguenots; Luis de Molina founds the so-called "Doctrine of Divine Grace," which kindles far-reaching religious disputes; Thomas Hobbes is born; Veronese dies (1588).

1589 Maria Rubens returns to Antwerp with her children, Peter Paul and Philip. Peter Paul attends grammar school in Antwerp and serves as page to a countess.

1589-1594: After the murder of King Henri III of France, the last Valois, the Bourbon rule begins with Henri IV, who first embraces Protestantism; the Russian church dissociates itself from Constantinople; William Lee invents the loom (1589). — After the breakdown of its political and nautical power, Spain finds itself in economic difficulties; Galileo undertakes his experiments with falling bodies from the Tower of Pisa; construction of the dome at St. Peter's, begun in 1573 according to the plans of Michelangelo, is completed by della Porta; Gerrit van Honthorst is born; Coello, court painter to Philip II, and Leone Leoni die; Caravaggio's "The Calling of St. Matthew" is taking form (1590). — In France the political autonomy of the guilds is failing; Boris Godunov, regent in Russia, has Demetrius, son of the tsar, murdered; Shakespeare's "Romeo and Juliet" is being produced; Jusepe de Ribera and Guercino are born (1591). — King Sigismund III of Poland establishes rule over Sweden; the Czech educator Comenius and the French graphic artist Jacques Callot are born; the French philosopher Michel de Montaigne dies; the Utrecht School of painting begins (1592). — The French king and Huguenot leader Henri IV converts to the Catholic faith; Jacob Jordaens and Matthäus Merian the Elder are born; the English dramatist Christopher Marlowe dies (1593). — Gustavus Adolphus II becomes King of Sweden; Galileo lays down the principle of the conservation of mechanical energy; Nicolas Poussin is born; Tintoretto and Mercator, as well as the composers Orlando di Lasso and Palestrina, die; Giovanni da Bologna executes the equestrian statue of Cosimo I in Florence (1594).

After his first artistic instruction with the landscape painter Tobias Verhaecht (1561-1631), Rubens works for several years in the atelier of Adam von Noort (1562-1641). Subsequently, Otto van Veen (1556-1629), leading representative of Romanism in Antwerp, becomes his teacher.

1595-1596: The first Dutch colony in East India is established; Galileo's pendulum laws are crystallizing; Torquato

Tasso dies; Mercator's "Atlas" appears posthumously (1595).
— France, England, and the Netherlands are at war against Spain's counterreformation attempts in France: Spain is forced to pull back; Spitzbergen is discovered; Descartes and Jan van Goyen are born (1596).

1597 The first certain work by Rubens which has been preserved is the so-called *Mechanic*, a small portrait in copper, dated 1587.

1597: The Shakespeare Company founds the Globe Theater in London; in Amsterdam the first women's prison, the so-called "workhouse," is established; François Duquesnoy and Martin Optiz are born; the frescoes in the Palazzo Farnese in Rome are painted by the Carracci brothers.

1598 Rubens becomes a member (master painter) of the Antwerp Guild of St. Luke. He thus acquires the right to instruct pupils.

1598-1599: Tsar Feodor I dies — Boris Godunov becomes his successor; the head of the Counterreformation, King Philip II of Spain, dies, leaving behind a large national debt; the Edict of Nantes, in which Henri IV assures the French Protestants religious freedom, temporarily ends the Huguenot wars; in Catholic Ireland outbreaks of violence are directed against the Protestant sovereignty; the decline of the Hanseatic League is accelerated by the abrogation of its privileges in England; Gian Lorenzo Bernini and Francisco de Zurbarán are born (1598). — The English statesman Oliver Cromwell, as well as the artists Francesco Borromini, Anthony van Dyck, and Velázquez, are born; Reni's "Portrait of Beatrice Cenci" and Annibale Carracci's "Madonna del Silenzio" take form (1599).

1600 Rubens journeys to Italy on May 9, where he is engaged as court painter to Duke Vincenzo Gonzaga in Mantua (to 1608). During this time the sovereign enables Rubens to

further his artistic education in various Italian cities, among others, in Genoa. In October Rubens stays in Florence on the occasion of the marriage of Maria de Medici to Henri IV of France.

1600: After his divorce from Margaret of Valois, Henri IV of France marries Maria de Medici, from the house of the grand duke of Tuscany; the English East India company is established; Galileo recognizes the law of inertia in bodies; Brahe and Kepler are working together; the telescope is invented; the Spanish dramatist Calderón, Claude Lorrain, and the Dutch painter Paulus Bor are born; Giordano Bruno and Luis Molina, the advocate of the doctrine of divine grace (Molinism), die.

1601-1602 Rubens is in Rome and is commissioned by Archduke Albrecht to paint three altar paintings for a chapel in Santa Croce in Gerusalemme: *St. Helena, Christ Crowned with Thorns,* and the *Elevation of the Cross.*

1601-1602: Robert Essex is executed following an attempted insurrection against Queen Elizabeth of England; Thomas Harriot develops the law of light refraction; Tycho Brahe develops an astronomical concept according to which the planets orbit the sun, while the sun orbits the earth; Kepler becomes the imperial astronomer and astrologer; Henri IV establishes a tapestry works (named Gobelins after a Parisian family of wool-dyers); Shakespeare's "Hamlet" is being produced; Caravaggio's "The Crucifixion of St. Peter" and "The Conversion of St. Paul" are taking form (1601). — The Dutch found the South African cape colony; the Dutch East Indian Company is created; Galileo develops his first proposals concerning his law of falling bodies; the flintlock gun begins to replace the matchlock gun; the French statesman Mazarin, the Italian opera composer Cavalli, and the artists Alessandro Algardi and Philippe de Champaigne are born; Caravaggio paints "The Calling of St. Matthew" (1602).

1603 Commissioned by the Prince of Gonzaga, Rubens goes on an official mission from 1603-1604 to the Spanish court in Valladolid. Rubens travels from Mantua via Florence to Livorno, where he sets sail on April 2. On April 22 he arrives in Spain. On July 11 Rubens delivers the gifts of Duke Vincenzo Gonzaga to King Philip III and the duke of Lerma in Valladolid. Peter Paul Rubens' brother, Philip, is conferred the degree of Doctor of Law in Rome.

Works: *Heraclitus Weeping* and *Democritus Laughing* (completed on July 6), *The Duke of Lerma on Horseback* (completed on November 23; cf. fig. 54). He declines the painting of ladies' portraits for the duke of Mantua in France.

1603: Queen Elizabeth of England dies; King James I, with whom the rule of the Scottish Stuarts begins, becomes her successor; following up on French seafarers who had already landed in Canada in 1594, France now presses farther forward into the "New France" overseas; Bellarmine's counterreformation "Little Catechism" appears and becomes extraordinarily widespread; Aert van der Neer is born.

1604 In the spring Rubens returns to Mantua.

1604: The Polish king Sigismund III loses the Swedish crown (cf. 1592) to Charles IX, who is sympathetic to the Reformation; Frederick of Logau is born; Shakespeare's "Othello" and "Measure for Measure" are taking form, as well as Karel van Mander's "Het Schilderboek"; Caravaggio paints his "Madonna in a Garland of Roses."

1605 Rubens works on two reproductions of Correggio for Emperor Rudolf II. The work is concluded on September 30. On May 25 three large canvases for the choir of the Jesuit church St. Trinita in Mantua are completed and are unveiled on June 5.

1605: In England the Gunpowder Plot, led by Catholics, prevents King James I from leaning toward the Catholic

Church; Poland achieves a victory over Sweden in the Battle of Kirkholm near Riga; Cervantes' "Don Quixote" and Jonson's "Volpone" are published; Elsheimer is painting his "Arcadian Landscape"; Annibale Carracci completes his work on the frescoes at the Farnese Palace.

1606 Between 1606 and 1608 Rubens makes several extended visits to Rome. July 1606: Rubens becomes ill. On December 2 Rubens takes over the commission for the high altar at the Church of Santa Maria in Vallicella.
Work: *Hero and Leander* (ca. 1606).

1606: Shakespeare's "King Lear" and "Macbeth" are being written; born are Rembrandt, Adriaen Brouwer, and the German painter and author of the first history of Germany, Joachim Sandrart, who will also visit Rubens later.

1607 Once again Rubens stays several months in Rome. On February 17 Rubens recommends the acquisition of "The Death of the Virgin" by Caravaggio to the duke of Mantua. On June 9 the first altar painting for Santa Maria in Vallicella is completed: *The Madonna Adored by St. Gregory and Other Saints* (cf. fig. 62).

1607: In North America Virginia is established as the first English colony; tobacco plantations are being started on which Negro slaves are put to work; the first performance of Monteverdi's "Orfeo" takes place in Mantua; the Bohemian copper engraver Wenzel Hollar is born; the Italian architect Domenico Fontana and the Dutch painter Gillis van Coninxloo die.

1608 In October Rubens completes the second composition of the altar painting for Santa Maria in Vallicella. On October 19 Rubens' mother, Maria, née Pypelincks, dies. On October 28 the artist sets out on the return trip to Antwerp, after the news of his mother's serious illness has reached him. On December 11 Rubens arrives in Antwerp. He moves into a house on Klosterstrasse.

1608: The so-called "Union," a Protestant defense alliance of southern German barons, is established; in Paraguay a Jesuit state is being formed; in Canada the city of Quebec is founded; the English poet John Milton is born; El Greco is painting his "Portrait of Cardinal Taverna" and Caravaggio his "Beheading of John the Baptist."

1609 Rubens paints the *Adoration of the Kings* (cf. fig. 56) for the Antwerp town hall; Abraham Janssens paints the allegory "Antwerp and the Schelde" for the same chamber. On September 23 Rubens is appointed court painter to the archbishops, the sovereigns of the Spanish provinces. On June 29 Rubens gains admittance to the Romanists' Guild. He establishes an extraordinarily successful atelier with a large number of ever-changing assistants. On October 3 Rubens marries Isabella Brant (born October 1591) in the abbey of St. Michael's in Antwerp.

Other Works: *Portrait of a Couple with a Child* (about 1609; cf. fig. 5), *The Dispute of the Holy Sacrament* (about 1609; cf. fig. 25), *Rubens and Isabella Brant under the Honeysuckle Bower* (1609–1610; cf. color plate 5).

1609: An armistice between Spain and the "renegade" Netherlands is drawn up, which lasts until 1621; the Catholic League, a defense alliance of the bishops of southern Germany, is established; the Charter of Rudolf II is signed, in which he assures the Bohemian estates of the realm full religious freedom and privileges; the last Moors are driven out of Spain; as the central European hub of the clearinghouse trade, the Bank of Amsterdam is founded; in Europe the first newspapers begin to appear regularly (in 1609 the first printed newspaper is published in Strasbourg; in 1631 the "Gazette de France" appears); Galileo proves the laws of falling bodies and undertakes the first telescope experiments; Shakespeare's "Sonnets" are published; Annibale Carracci dies; Elsheimer's painting "Philemon and Baucis" and Reni's Roman ceiling painting "Aurora" are taking form.

1610 On January 20 Rubens is accorded exemption from taxes in Antwerp. On May 7 he begins work on the *Elevation of the Cross* (cf. fig. 26), concerning which he closes a contract with St. Walpurga's Church in Antwerp on June 17. September 29: Rubens and Isabella donate the *Madonna Adored by St. Gregory and Other Saints* (cf. fig. 62), the first composition of the Vallicella altarpiece, which Rubens had taken with him to Antwerp, to St. Michael's Church for his mother's tomb. In November of this year the artist buys a plot of land on the Wapper on which the Rubens' House, restored in the nineteenth century, is under construction until 1615.

1610: King Henri IV of France is assassinated by a Catholic; his successor is Louis XIII, born in 1601; in reality it is Queen Maria de Medici who subsequently first rules the government; while experimenting with the possibilities of the telescope, Galileo discovers moons of Jupiter, mountains on the moon, and the Milky Way; Adriaen van Ostade and David Teniers the Younger are born; Caravaggio and Adam Elsheimer die; the latter is deeply mourned in a letter of Rubens.

1611 On March 13 Rubens begins work on the *Descent from the Cross* (cf. color plate 2), for which a contract of purchase is closed on September 7 with the Antwerp Guild of Harquebusiers. On March 21 his daughter Clara Serena is born. On May 11 Rubens sells the picture *Juno and Argus*. On August 28 Philip Rubens, the painter's brother, dies in Antwerp.
Works: *The Dying Seneca* (about 1611; cf. fig. 23), *Justus Lipsius and His Pupils* (about 1611; cf. fig. 21).

1611: There are general inflationary developments in Europe, brought about by the importation of precious metals from the colonies; in England the authorized Bible translation, the "King James Bible," is published; Shakespeare's "The Winter's Tale" and "The Tempest" are taking form; Reni paints "The Slaying of the Children of Bethlehem" and "Samson, the Victor."

1612 Rubens completes the central panel of the *Descent from the Cross* (cf. color plate 2). Further work is done on two altars for Brussels (*Story of Job* altar) and Ghent (*The Conversion of St. Bavon* altar), as well as an altar painting of the *Resurrection of Christ* (with an epitaph to Moretus). Mention is made of the works: *Ganymede, Prometheus, Venus and Adonis,* and a *Self-Portrait with Isabella Brant.*
Further work: *Hercules Drunk* (about 1612; cf. fig. 34).

1612: The Andromeda nebula is discovered; the English poet Samuel Butler and the French painter Pierre Mignard are born; Federico Barocci and the Italian poet Guarini die.

1613 On July 1 Rubens is elected dean of the Guild of Romanists. In the Church of St. Nicholas at Brussels, the *Story of Job* altarpiece, commissioned by the Guild of Musicians, is erected.
Works: *Jupiter and Callisto* (signed and dated 1613), *Venus, Ceres, Bacchus, and Cupid* (ca. 1613; cf. fig. 32), *Hero Crowned by Victory* (ca. 1613; fig. 33), *Pausias and Glycera* (ca. 1613), *The Toilet of Venus* (ca. 1613–1615; cf. fig. 35), *The Doubting Thomas* (ca. 1613–1615; cf. fig. 31).

1613: In Russia domestic strife comes to an end with the ascent to power of the House of Romanov under Tsar Michael; the Globe Theater burns down during the first performance of Shakespeare's "Henry VIII"; in a "provocative" letter to Castelli, Galileo defends the view that the Bible cannot be authoritative on questions in the natural sciences; on this basis the first Inquisition trial against Galileo is conducted; the French moral philosopher La Rochefoucauld is born.

1614 Beginning of April: Helena Fourment, later to become Rubens' second wife, is baptized in Antwerp. June 5: The eldest son of the painter, Albrecht, is baptized under the sponsorship of Archduke Albrecht. June 30: Rubens completes his year as dean of the Guild of Romanists and gives

them his work *Sts. Peter and Paul*. August 2: The altarpiece *Descent from the Cross* is dedicated. August 4: Rubens announces the completion of two portrayals of *Seneca*.

Other Works: *Cupid Carving a Bow* (ca. 1614), *Dead Christ Mourned by the Holy Women* (ca. 1614), *The Flight to Egypt* (ca. 1614).

1614: Maria de Medici dissolves the Estates-General in France; the war between Sweden and Russia begins; sometime around this year the Dutch colony of New Amsterdam is established, which is later to become New York; Neper draws up the first logarithmic table; construction of the Blue Mosque in Constantinople comes to an end; El Greco dies; Lodovico Carracci's "Allegory of Truth and Time" and Domenichino's "The Last Communion of St. Jerome" are taking form.

1615 Rubens, in whose atelier Jan Brueghel and Frans Snyders (since 1609), among others, are active, turns out a *Madonna* and other portraits of Archbishop Albrecht and his wife, who commissioned the work. *The Doubting Thomas* begun in 1613 is completed. Between ca. 1615 and 1620 numerous paintings of hunting scenes are produced.

Other works: *Head of a Young Girl* (ca. 1615), *The Death of St. Anthony Eremita* (ca. 1615; cf. fig. 22).

1615: Galileo is called before a court of the Inquisition because of his "heresy"; the second volume of "Don Quixote" is published; Salvatore Rosa and the Dutch painter Govaert Flinck are born.

1616 The young Anthony van Dyck joins Rubens' atelier as an assistant (until 1621). In December Rubens travels to Brussels, where he produces portraits of the archdukes.

Works: The large *Last Judgment* (ca. 1616; cf. fig. 38), *Portrait of Hendrik van Thulden* (ca. 1616; cf. fig. 52), *Jupiter and Antiope* (1616), *Boy Playing with Bird* (ca. 1616; cf. fig. 7), *St. Francis Receiving the Stigmata* (ca. 1616), *The Battle of the Amazons* (ca. 1616 to 1618; cf. color plates 6 and 7).

1616: Copernicus' writings are put on the "Index Expurgatorius"; Andreas Gryphius is born; Cervantes and Shakespeare die; Lodovico Carracci's "Martyrdom of St. Margaret" and Frans Hals' "Banquet of the Officers of the St. George's Guild" take form.

1617 From ca. 1617 (to ca. 1627) Rubens obtains commissions for a series of cyclical paintings. He creates among others the Story of the consul *Decius Mus* (cf. fig. 48), the History of *King Constantine* (cf. fig. 61) in a series of tapestry designs, the life of *Maria de Medici,* as well as a tapestry design for a cycle of allegorical portrayals of the *Triumph of the Last Supper.* Work begins on the high altar of St. John's Church in Mecheln.
Other works: *The Christ à la Paille* (with the Michielsen Epitaph, 1617), *St. Sebastian* (ca. 1617; cf. fig. 43), *The Prodigal Son* (ca. 1617-1618; cf. fig. 41), *The Miracles of St. Francis Xavier* (ca. 1617-1618; cf. figs. 45 and 46).

1617: Louis XII exiles his mother, Maria de Medici, to Blois; the war between Sweden and Russia ends with Sweden's acquisition of land; in Amsterdam the first grain exchange is opened; Murillo and Gerard Terborch, as well as the German poet Hofmann von Hofmannswaldau, are born; the Dutch copper engraver Hendrik Goltzius and the Spanish scholar Francisco Suarez die; Domenichino paints "Diane Hunting," van Dyck (still in Rubens' atelier) the "Crucifixion."

1618 On March 23 Rubens' son Nicolas is born. April 28: in a list of offerings of the Rubens atelier the following works, among others, are cited as being up for sale: *Daniel in the Lion's Den, Leda, the Swan and Cupid, Lion Hunt, Susanna.*
Other Works: *Christ and the Repentant Sinners* (ca. 1618; cf. color plate 3), *Castor and Pollux Seizing the Daughters of Leucippus* (ca. 1618; cf. color plate 5), *Landscape with Cows and Milkmaid* (ca. 1618-1620; cf. fig. 42).

1618: In this year occurs the Prague Defenstration and the beginning of the Thirty Years' War with the insurrection of the Bohemian Protestants, whose religious freedom, assured to them in the charter of 1609, was being restricted; the English physician William Harvey discovers the two systems of blood circulation; the Orion nebula is discovered; the English seafarer and pirate Walter Raleigh and the founder of the new "bel canto" style of singing, the Italian composer Caccini, die.

1619 Rubens secures the engraving rights for his paintings in Brabant and France; the Estates-General at the Hague deny him such rights.
Work: *Perseus and Andromeda* (ca. 1619-1620; cf. fig. 40).

1619: There are internal struggles in the Calvinist Reformed Dutch Church; the transportation of slaves from Black Africa to North America begins; Kepler develops the third law of planetary motion; Scheiner undertakes experiments on the optics of the eye; Dudley develops coke as a substitute for charcoal; the French poet Cyrano de Bergerac, Willem Kalf, and Philips Wouwerman are born; Lodovico Carracci dies; in Brussels the fountain figure of the Manneken-Pis is created.

1620 March 29: Rubens receives a commission for the pictorial furnishing of the Antwerp Jesuit Church with 39 ceiling paintings and three altar pictures.
Works: *The Crucifixion ("Le coup de lance,"* 1620; cf. color plate 9), *Landscape with a Cart Stuck in the Mud* (about 1620), *The Madonna Surrounded by Garland and Boy Angels* (ca. 1620; cf. fig. 8), The small *Last Judgment* (ca. 1620; cf. fig. 39, color plate 4).

1620: The Catholic League under Tilly is victorious over the Protestant Union under Frederick V. Protestantism is suppressed in Bohemia; the Puritan fathers of the "Mayflower" found the colony of New England in North America;

the thermometer is developed; tobacco smoking is introduced to Germany; Aelbert Cuyp is born; Bartolommeo Manfredi and Carlo Saraceni die; Bernini's sculpture "The Rape of Proserpine" and van Dyck's "St. Sebastian" are taking form.

1621 Works: *St. Michael* (1621), *Lion Hunt* (ca. 1621; cf. fig. 59).

 1621: After the expiration of the armistice, the Netherlands defends anew its independence from Spain, when Philip IV ascends to the throne; between 1621 and 1629 the Huguenots are defeated in several wars; Tilly occupies the Palatinate; Van Dyck goes to Italy.

1622 In this year Rubens begins his diplomatic activity, which then reaches its peak in 1628. In the beginning of January Rubens travels to Paris in order to negotiate on the Medici gallery, finally unveiled in May 1625, which is to house the great cycle on the life of Maria de Medici. At the end of February Rubens returns from Paris to Antwerp. In May Rubens submits the plan for the Medici gallery.
Works: *The Vision of the Monogram of Christ* (ca. 1622-1623; cf. fig. 61), *Portrait of Susanna Lunden ("le Chapeau de paille,"* ca. 1622-1625).

1623 February: Rubens is given a commission for the enlargement of the *St. Bavon* altar in order to make room for a Rubens painting. May–June: He makes further trips to Paris concerning the Medici gallery. Maria de Medici and Richelieu inspect plans for the Medici paintings. Late October: Rubens' daughter Clara Serena, the eldest child of the artist, dies.
Work: *Isabella Brant* (ca. 1623; cf. fig. 11).

 1623: A conspiracy against Prince Morris of Orange is uncovered and crushed in the Netherlands; a diplomatic understanding arises between Spain and England; Tilly invades Westphalia; Velázquez is employed as court painter by

Philip IV and paints the Spanish royal family; Rembrandt begins his instruction in painting with Swanenburgh; Bernini's sculpture "Apollo and Daphne" and Hals' "Yonker Ramp" are taking form; the first complete edition of Shakespeare's works is published.

1624 January 29: Rubens submits a request to the Spanish king to be granted a patent of nobility. On June 5 the artist is raised to the rank of Spanish nobility. In early summer Rubens undertakes several diplomatic journeys between Brussels and Spinola's camp. September 25: Prince Ladislaus Sigismund of Poland visits the Rubens house. September 27: Work on the *St. Bavon* high altar in Ghent comes to an end. Mid-October: Rubens conducts secret peace and armistice negotiations for Spain, whose General Spinola is laying siege to the Dutch town of Breda. December: The Medici gallery is completed.

Work: The *Adoration of the Kings* (1624; cf. fig. 49, color plate 10).

1624: England prepares itself for a new war with Spain and signs a treaty with the Netherlands; the Netherlands also signs a treaty with France, where Richelieu, as an advocate of absolutism, becomes the chief minister to Louis XIII and a decision maker on foreign policy; large sections of Oslo are destroyed by fire — during the reconstruction of the city it acquires the name of Kristiana; Angelus Silesius and Guarino Guarini are born; Jackob Böhme, Dirck van Baburen, the foremost representative of the Utrecht School of painting, and the Dutch genre and landscape painter Buytewech die; Frans Hals paints the "Jolly Toper," van Dyck the "Portrait of Cardinal Bentivoglio."

1625 In the beginning of the year Rubens remains in Paris for some time. In April he submits a plan for *The History of Henri IV,* intended for the Medici gallery. During the same month King Louis XIII visits the Medici gallery, which is dedicated in the following month. July 10: The Spanish infanta Isabella

visits the Rubens House. November 19: The duke of Buckingham arrives in Antwerp on his way to the Hague and also visits the Rubens House.

Works: Work commences on *The Assumption of the Virgin* for the Cathedral in Antwerp (1625; cf. fig. 50), *Self-Portrait* (now at Windsor Castle; ca. 1625; cf. fig. 13).

1625: Denmark, under King Christian IV, is drawn into the Thirty Years' War; King James I, the son of Mary Stuart, dies — the absolutist Charles I becomes his successor; Breda is seized by Spanish troops — the Spaniards, however, are not able to follow up on this victory over the Dutch troops under Prince Frederick Henry, who succeeded Prince Morris after his death in June; Grimmelshausen and the Dutch painter Paulus Potter are born; Jan Brueghel the Elder ("Sammet-Brueghei") dies.

1626 On May 11 the *Assumption of the Virgin* (cf. fig. 50) is brought from the Rubens House to the Cathedral at Antwerp. June 4: Rubens becomes the guardian of Jan Brueghel's children. June 20: Isabella Brant, the wife of the artist, dies. Late December 1626: Rubens suffers the first attacks of gout, which will increasingly impede him until his death.

1626: The Battle at the Dessau Bridge occurs: Wallenstein defeats Count Ernst and subsequently occupies the Baltic countries; Tilly defeats Christian IV of Denmark and his Protestant troops at Barenberg; France and Spain come to an agreement at the Peace of Moucon; Louis XIII makes peace with the Huguenots; Santorio uses the thermometer to measure fever; in Rome St. Peter's is dedicated; Jan Steen is born; the English statesman and philosopher Francis Bacon dies.

1627 July–August: Rubens travels to the Netherlands (Rotterdam, Delft, Amsterdam, Utrecht), ostensibly to become acquainted with the country's painters of renown, but in actuality to enter into negotiations with English mediators. Work: Completion of *The Assumption of the Virgin* for Augsburg (1627).

1627: Wallenstein and Tilly conquer Holstein; Wallenstein is forced to abandon his siege of Stralsund; the first German opera, "Dafne" by Schütz, is performed; the English king Charles I gains possession of the Mantua collection of paintings; Claude Lorrain arrives in Rome — his first landscapes are taking form; the Dutch painter Samuel van Hoogstraaten is born; Luis de Gongora and Adriaen de Vries die; Rembrandt's painting "The Money Changer" and Hals' "Married Couple" are taking form.

1628 Between mid-September 1628 and the end of April 1629 Rubens is in Spain on a diplomatic mission, as well as in fulfillment of artistic commissions; there he reports to King Philip IV and, on September 28, to the Spanish council of state on his negotiations with the English mediators.
Works: Work begins on *The History of Henri IV* (January 1628), *The Virgin Surrounded with Saints* (1628), *Philip IV on Horseback* (1628), *Self-Portrait* (Florence; ca. 1628), *Portrait of Gaspar Gevartius* (ca. 1628; cf. fig. 53).

1628: Wallenstein becomes the duke of Mecklenburg; Richelieu conquers La Rochelle; the Huguenots encounter further difficulties; the duke of Buckingham is murdered in Portsmouth; Pit Hein conquers the Spanish Silver Fleet; England adopts the "Petition of Right"; the English poet John Bunyan and Jacob van Ruisdael are born; Francisco Ribalta dies; Poussin is commissioned to paint "The Martyrdom of St. Erasmus" for St. Peter's Basilica; Velázquez's painting "Christ on the Cross" is taking form.

1629 On April 29 Rubens leaves Madrid, having completed various portraits of the king and the queen, as well as of the infanta Marguerita. Via Paris, Brussels, Antwerp, and Dunkirk, he arrives in England as special emissary of the Spanish crown in order to hold peace negotiations. In June Rubens has three audiences with King Charles I. The stay in England extends through March 1630. On October 3 Rubens is conferred the Master of Arts degree.
Work: *War and Peace* (1629; cf. fig. 66).

1629: In the Peace of Lübeck, Denmark withdraws from the struggles of the Thirty Years' War; peace agreements are drawn up between France and Savoy, and France and England; the war between Sweden and Poland ends with Sweden's acquisition of land; the Spanish theater flourishes, with Lope de Vega and Calderón; Bernini is put in charge of the construction of the towers and layout of the square at St. Peter's; the Dutch painter of interiors Pieter de Hooch is born; Carlo Maderna, Hendrik Terbrugghen, and Rubens' teacher, Otto van Veen, die.

1630 March 3: Rubens has a farewell audience with King Charles I. He is knighted at Whitehall. December 6: Rubens enters into a second marriage with the young Helena Fourment. Work: *The Miracle of St. Ildefonso* (ca. 1630–1632; cf. fig. 78).

1630: Wallenstein is dismissed by the emperor: the Swedish war begins after the Swedish king Gustavus Aldolfus lands in Pomerania; a peace agreement between England and Spain is signed; the German painter Michael Willman is born; Kepler dies, as well as the Dutch painter Esaias van de Velde; the following works are taking form: van Dyck, "The Mourning of Christ"; Hals, "Nurse and Child"; Reni, "The Archangel Michael Triumphs over the Devil"; Velázquez, "Apollo in Vulcan's Forge."

1631 Rubens undertakes various diplomatic activities; he attends and accompanies, among others, the queen mother Maria de Medici, who has fled France and makes a stop in Antwerp in August. Rubens travels to the Hague, where he meets with Prince Frederick Henry of Orange.
Work: Work on the *Miracle of St. Ildefonso* altarpiece (cf. fig. 78).

1631: Tilly conquers Magdeburg but suffers a defeat in the Battle of Breitenfeld against Swedish troops; Vesuvius erupts; Comenius publishes his "Informatorium of the School for Mothers"; Rembrandt moves from Leiden to Amsterdam

and in the succeeding years is in strong competition with Rubens' style.

1632 January 28: The first child is born from the union between Rubens and Helena Fourment — their daughter Clara Johanna. August: Rubens negotiates in Brussels and Liége with emissaries of the Dutch Estates-General.
Works: *The Offering to Venus* (ca. 1632; cf. fig. 77), *The Judgment of Paris* (ca. 1632-1635).

1632: Tilly dies; Wallenstein again becomes an imperial general; Gustavus Adolphus II of Sweden falls in the Battle at Lützen; in North America the colony of Maryland is founded; Luca Giordano, John Locke, Nicolaes Maes, Spinoza, and Jan Vermeer van Delft are born; Brouwer settles in Antwerp; van Dyck becomes court painter in London; Rembrandt paints "The Anatomy Lesson of Dr. Tulp."

1633 July 12: Rubens' son Frans is born.
Works: *The Adoration of the Kings* (1633), *Conversation `a la Mode* (ca. 1633; cf. color plate 14), *The Rondo (Dance of Italian Peasants)* (ca. 1633; cf. color plate 17).

1633: In England the Baptist sect is forming; Galileo renounces the teachings of Copernicus during his second Inquisition trial; Pietro da Cortona begins the ceiling painting in the Palazzo Barberini; Pieter Lastman dies; taking form are: Bernini's "Tabernacle in St. Peter's Basilica," Callot's series of etchings on "The Horrors of War," van Dyck's "Portrait of Charles I," Hals' "The Adriaen Marksmen," Rembrandt's "Descent from the Cross" and "Saskia."

1634 Works: Start on the reconstruction of the Afflighen altar with Rubens' *Christ Bearing the Cross* (cf. fig. 69); work on *The Joyous Entry of the Cardinal-Infante Ferdinand, The Holy Family with SS. Elizabeth and Johanna* (ca. 1634), *Self-Portrait* (Louvre; ca. 1634; cf. fig. 18).

1634: Wallenstein is dismissed, then murdered, because he had entered into negotiations with the Protestants; the Swedish Protestant troops are defeated at Nördlingen; the Cardinal-Infante Ferdinand is joyously greeted in Brussels; in Oberammergau the first passion play is performed as a votive offering in the plague year of 1633; Rembrandt marries Saskia; Claude Lorrain's "Port at Sunset," Poussin's "Helios and Phaëton," and Rembrandt's "Self-Portrait with Velvet Beret" are taking form.

1635 April: Cardinal-Infante Ferdinand visits Rubens. May 3: His daughter Isabella Helena is born. May 12: Rubens purchases Castle Steen and lands (at Mecheln). December: A cycle of ceiling paintings from the Rubens' atelier intended for the decoration of Whitehall Palace arrives in England (cf. fig. 65).
Works around 1635: *Andromeda* (cf. fig. 74), *Bathsheba at the Fountain* (cf. color plate 13), *Return from the Fields* (cf. fig. 80), *Helena Fourment with Her Firstborn Son Frans* (cf. fig. 12), *Harvest Landscape with Rainbow* (cf. color plates 18 and 19).

1635: There is war between Sweden and France; Louis XIII declares war on the Spanish Netherlands and makes a pact with the Free States of the Netherlands and France; on Richelieu's inducement the Académie Française is formed from the society for promoting the mother tongue; Calderón becomes court theater director in Madrid; Lope de Vega and Jacques Callot die; taking form are Bernini's "David with the Head of Goliath," Rembrandt's "Self-Portrait with Saskia," Ribera's "Annuciation," and Velázquez's portraits of the king, the princes, and the duke of Olivarez on horseback.

1636 April 15: Rubens is appointed court painter to the Cardinal-Infante Ferdinand and is sworn in as such on June 13. November: The artist is commissioned by the Infante to execute a decoration for the Torre de la Parada in Madrid.
Works: *The Castle at Steen, Autumn* (1636; cf. color plate 20), *The Massacre of the Innocents* (ca. 1636; cf. fig. 71), *The Rape of the Sabines* (ca. 1636; cf. fig. 72), *Christ Bearing the*

Cross (ca. 1636–1637; cf. fig. 69), *The Banquet of Tereus* (ca. 1635–1637; cf. fig. 73).

1636: The Swedes win a victory at Wittstock over the Imperial troops and Saxony; in North America the colony of Rhode Island is founded; the first North American university, the Calvinist Harvard University, is organized; cinchona bark is gradually introduced into European medicine for the control of malaria; the Dutch landscape painters Adriaen van de Velde and Melchior d'Hondecoeter are born; Rembrandt paints the "Return of the Prodigal Son."

1637 March 1: His son Peter Paul is born. April: Cardinal-Infante Ferdinand makes a stop in Antwerp and meets with Rubens. Late in the year: 112 pictures for the Torre de la Parada are completed for the most part.
Other Works: Design for the *High Altar* of the Church of the Brothers of Our Lady in Antwerp, *The Elevation of the Cross* for the high altar in Afflighen (1637); *The Horrors of War* (1637–1638; cf. fig. 68, color plate 12).

1637: Prince Frederick Henry reconquers Breda; in England the first battleship with three decks is constructed; the Dutch tulip trade is ruined through poor speculation; Descartes develops a rationalistic philosophy in "Discourse on Method"; the English dramatist Ben Jonson and the Italian painter Caracciolo die.

1638 May: The Torre de la Parada pictures arrive in Madrid. June: A new commission for Torre de la Parada is handed over to Rubens. May, June, July, October: Severe attacks of gout impede the artist. December: Rubens is seriously ill and is administered extreme unction (December 11).
Works: *The Crucifixion of St. Peter* for the St. Peter's Church in Cologne (ca. 1638; cf. fig. 70), *The Woman in the Pelisse* (ca. 1638; cf. fig. 75).

1638: The Netherlands invades Ceylon at the expense of Portugal's colonial holdings; Maria de Medici leaves the

Spanish Netherlands and sails to England; Galileo puts forth the first modern physics textbook with his "Discorsi"; torture is abolished in England; Meindert Hobbema is born; Adriaen Brouwer and Pieter Brueghel the Younger ("Brueghel's Hell") die.

1639 April: Charles I of England presents a medallion to Rubens. The artist works on pictures for Philip IV of Spain: *Andromeda, Hercules, Rape of the Sabines,* and *Reconciliation of the Romans and Sabines.*
Other Works: *The Judgment of Paris* (1639; cf. fig. 82), *St. Augustine* (1639), *St. Thomas* (1639), *St. Cecilia* (ca. 1639–1640; cf. fig. 76), *Madonna with Saints* (ca. 1639; cf. fig. 79), *The Three Graces* (ca. 1639; cf. color plates 15 and 16).

1639: Jean Racine is born; Thomas Campanella ("City of the Sun") and Martin Opitz die; Poussin paints "Shepherds in Arcadia," Rembrandt, the "Portrait of the Artist's Mother."

1640 Beginning of the year: Rubens is seriously ill with gout. March: His hands are crippled. May 27: Rubens has a new will drawn up. May 30: Rubens dies. June 2: The funeral rites are held. From June 8 on: Inventory is taken of the Rubens' House.